THE ART OF BIRDS

UNIVERSITY PRESS OF FLORIDA

Florida A&M University, Tallahassee

Florida Atlantic University, Boca Raton

Florida Gulf Coast University, Ft. Myers

Florida International University, Miami

Florida State University, Tallahassee

New College of Florida, Sarasota

University of Central Florida, Orlando

University of Florida, Gainesville

University of North Florida, Jacksonville

University of South Florida, Tampa

University of West Florida, Pensacola

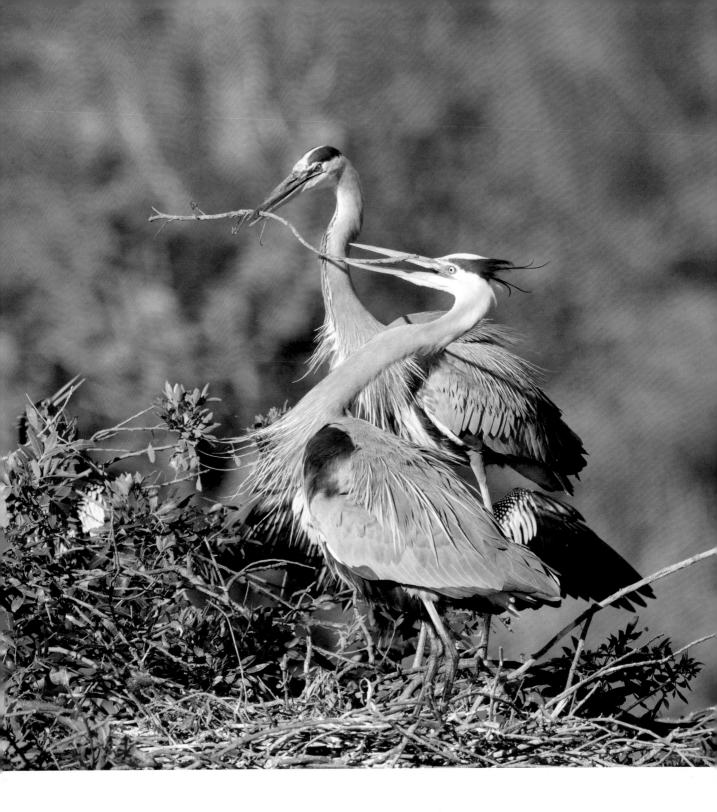

UNIVERSITY PRESS OF FLORIDA

Gainesville · Tallahassee · Tampa · Boca Raton · Pensacola · Orlando · Miami · Jacksonville · Ft. Myers · Sarasota

THE ART
OF BIRDS

Grace and Motion in the Wild

Jim Miller

Published in the United States of America. Printed in Canada on acid-free paper.

26 25 24 23 22 21 6 5 4 3 2 1

Library of Congress Control Number: 2020938177

ISBN 978-0-8130-6676-9

The University Press of Florida is the scholarly publishing agency for the State University System of Florida, comprising Florida A&M University, Florida Atlantic University, Florida Gulf Coast University, Florida International University, Florida State University, New College of Florida, University of Central Florida, University of Florida, University of North Florida, University of South Florida, and University of West Florida.

University Press of Florida
2046 NE Waldo Road
Suite 2100
Gainesville, FL 32609
http://upress.ufl.edu

For Cindy and Joe

CONTENTS

ACKNOWLEDGMENTS

Bird photography is often a solitary activity, mainly in the act of capturing the initial images. However, to produce final photographs, to arrange an opportunity to exhibit and sell them, and certainly to be able to assemble them in a book are acts of relationships and community. I am most grateful for the support and enjoyment of those who have found the photos artistically satisfying, and who continue to attend exhibitions, acquire photos and live with them in their homes and offices.

I was introduced to birds by Joe Hutto, a fellow archaeology student, a colleague, a naturalist, and a life-long friend. We shared many field trips, surveys, and excavations throughout Florida, often in places that were "old Florida" before that was a distinction. These places and their wildlife were captivating to me decades ago, and still are today.

The craft of bird photography is learned from others who have mastered the techniques and the practice; there is no curriculum. Rather, each person learns in their own multiple ways—from books, over the internet, in a workshop, or by following an expert. I would like to acknowledge the guidance and friendship of Arthur Morris, whose famous book started me down the path, and whose regular internet posts reach thousands of photographers around the world each week. Thank you, Arthur, it has been a great pleasure.

My approach to bird photography as a form of artistic expression developed because I was welcomed into a supportive community of artists, collectors, gallery owners, and gallery directors. I sincerely thank Tom Eads, of Thomas Eads Fine Art, who included me in his gallery's opening exhibition, and Mary MacNamara, owner of Signature Art Gallery, for representation, opportunities, and support for more than a decade. Allys Paladino-Craig, former Director of the Florida State University Museum of Fine Arts, has always been encouraging. She kindly arranged exhibitions and acquired pieces for

the Museum's permanent collection. 621 Gallery in Tallahassee and Gadsden Art Center and Museum in Quincy, Florida, arranged juried exhibitions and openings I will always remember with fondness. Thank you to Grace Robinson, Executive Director, and Angie Barry, Curator of Exhibitions and Collections, and Anisse Ford, Education Director, for including me in the continuing growth of Gadsden Art Center and Museum as a cultural, educational, and economic center of excellence.

I gratefully acknowledge those who work so diligently to acquire, manage, protect and provide public access to conservation lands. In all levels of government and in non-profit organizations, these dedicated professionals are a major reason it is still possible to watch and photograph birds in their natural habitats.

Thank you most of all to Cindy Miller. Together we have enjoyed art of so many different kinds, with so many wonderful people, and in so many places. It continues to be a great joy.

THE ART
OF BIRDS

INTRODUCTION

Why are birds beautiful? I have been asking that question for a couple of decades, since I took up bird photography, because each time I peer through the camera lens I am captivated. Over the years the chance to watch and photograph birds in their natural environments has led me to many special places and wonderful sights. Through bird photographs I can capture and share some of those experiences and perhaps convey some of their emotional content.

How did birds and their habitats come to be in their present configuration? How is that complex interaction ongoing now, and what will it look like in the future? As an archaeologist I have always been interested in time and space, in the differences between our present view as a snapshot, a moment in time, and the long history of environmental change that has led up to the present condition. I am always curious about how and why things are as they are now. I have learned that environment is the context for form, function, and behavior expressed in living things. Similarly, that evolution is the fundamental organizing principle for birds as well as people. Birds and their environments have been engaged in a complex and changing network of adaptation over millions of years.

To further explore how bird populations and their environments have changed over time, excerpts from narratives and journals of early naturalists accompany many of the photographs. These accounts from a time before the profound changes of modern settlement reveal a Florida we can mostly only imagine. The accounts of John and William Bartram of their visits to East Florida during the mid-1700s revealed to American and European readers the richness and variety of the largely unsettled peninsula. In the 1830s and '40s, John James Audubon traveled through the eastern half of the young nation, including the Territory of Florida, studying and depicting birds

from life. His monumental *Birds of America* and *Ornithological Biography* not only established an American ornithology based on a lifetime of observing birds in the wild, they presented a revolution in bird illustration: large portraits of exquisite detail often depicting dramatic representations of natural behavior. Another important source of quotations is the comprehensive series of life histories compiled by Arthur Cleveland Bent for the U.S. National Museum, especially those of North American wetland birds published in the 1920s and '30s. Excerpts from these early authors not only describe conditions that may no longer exist, they also add the charmingly descriptive and somewhat romantic flavor of this less technical period of bird study.

By concentrating on birds of large size, the egrets, herons, cranes, and others, it is possible to capture poses, gazes and behaviors that we can relate to very directly. Large birds have their own distinctive displays, postures, and routines that can be read with some practice and experience. Surprisingly, we respond emotionally to depictions of these, not just as pleasing images, but also as a window into the lives of fellow creatures. In making a photograph, the bird is revealed as an individual rather than a distant object; eye contact is established, and as the image is created, bird and human sometimes consider each other consciously. The exquisite biological forms that are the result of millions of years of evolution are often isolated and clarified. In the bill, the wing, the foot, the plumage, the eyes, the elegance of form follows the necessity of function. And, most important, I am always amazed that the forms and behaviors that evolution has produced in birds for courtship, display, and expression are so compelling to people.

What makes bird photography art—or not? I like the definition that art is a communication of emotion in the viewer through objects created for that purpose. One approach to bird photography is to capture the moment, to document what happened where and when. What did it look like? Another approach is to make decisions about the process of artistic creation that contribute to communication of emotion to the viewer. Photographers can use the same devices as the painter, the printmaker, or the watercolorist: composition, tension, proportion, movement, rhythm, harmony, perspective, color, contrast, balance, symmetry, and simplicity, for example. Techniques can be used in combination, intensifying the emotional reaction in the same way that a good cook combines and concentrates flavors in a meal. The product is greater than the sum of its parts.

Aesthetically, many of the photographs explore the boundary between

representation and abstraction. As they present more detail, they become less the birds we know. I sometimes search for the tension point where the image is at once bird and not-bird. More importantly, my approach involves finding subjects that are exceptionally compelling to me, capturing the elements that contain that power, and enhancing the effect on the viewer through various choices in exposure, editing, printing, and presentation. I am fascinated by birds in many ways, but I value them most highly as subjects for photographs that produce a pleasing emotion in me, and I hope, in others. These images rely on techniques like extreme close-up, tight cropping, striking color, simple composition, and plain backgrounds to reveal birds as most people never see them.

My photographic approach involves a series of time-honored techniques that would be standard procedure for any photographer of natural subjects. They comprise a simple set of tools conservatively applied to produce something that is not far from the reality of the subject as shot. I use high quality equipment for capturing images, including combinations of camera body, tripod, lens, and sensor or film that will produce a close-up image of a distant object at the highest resolution and fidelity. I have used Canon, Nikon, Panasonic, and Sony cameras, with professional series prime and zoom lenses ranging from 24mm to 600mm, along with 1.4x and 2x tele-extenders. It is easy to become obsessed with the latest equipment, as photographic technology is advancing rapidly; every few years what was once difficult or impossible becomes the new normal. Current equipment will readily capture a dozen or so high-resolution, sharply focused, highly magnified images of active and flying birds each second. Each image is slightly different, and almost always, one stands out as the most compelling photograph. All my image files are processed in Photoshop, usually for cropping, leveling, color adjustment, and exposure adjustment. I remove dust spots and clean backgrounds, but do not feel comfortable with edits that would misrepresent the original elements that were photographed.

For years, I have been printing on Kodak Endura metallic paper, as it presents a wonderful three-dimensional depth in the proper light. I have found acrylic face-mounts to be effective, especially where the image is strong enough in composition, detail and quality to stand quite alone without mat or frame. Finally, over time, I have produced larger and larger prints, made possible by improved sensors that produce large digital files and by sophisticated commercial printers. Like a movie theatre compared to a smartphone, large images have a greater emotional effect.

So, as you look at the photos, watch for the effects of pleasing composition such as use of the rule of thirds or strong diagonals; watch for bilateral symmetry, radial symmetry, fluid curves suggesting motion, contrast or complementarity in colors or texture or brightness. Watch for intricate detail, tension between abstraction and representation, the unexpected, the unknown revealed or resolved. Watch for variety in biological form and function as an expression of adaptation and evolution; watch for conditions of environment to which the birds are fit. Watch for aspects of behavior and form that exist to attract other birds—and that attract you as well. And, consider the marvel that birds and humans find the same traits of appearance and behavior aesthetically pleasing, whether for purposes of selecting a mate or as an object of artistic appreciation.

I have had the rare privilege of working in and studying every region of Florida, researching and reporting on how people and environment interact and change each other over thousands of years. For me, photography is one path to explore the present and the past, to view the natural world through one particular lens, literally and figuratively. The following photographs are my way of sharing some of the feelings and emotions that natural Florida evokes.

PORTRAITS

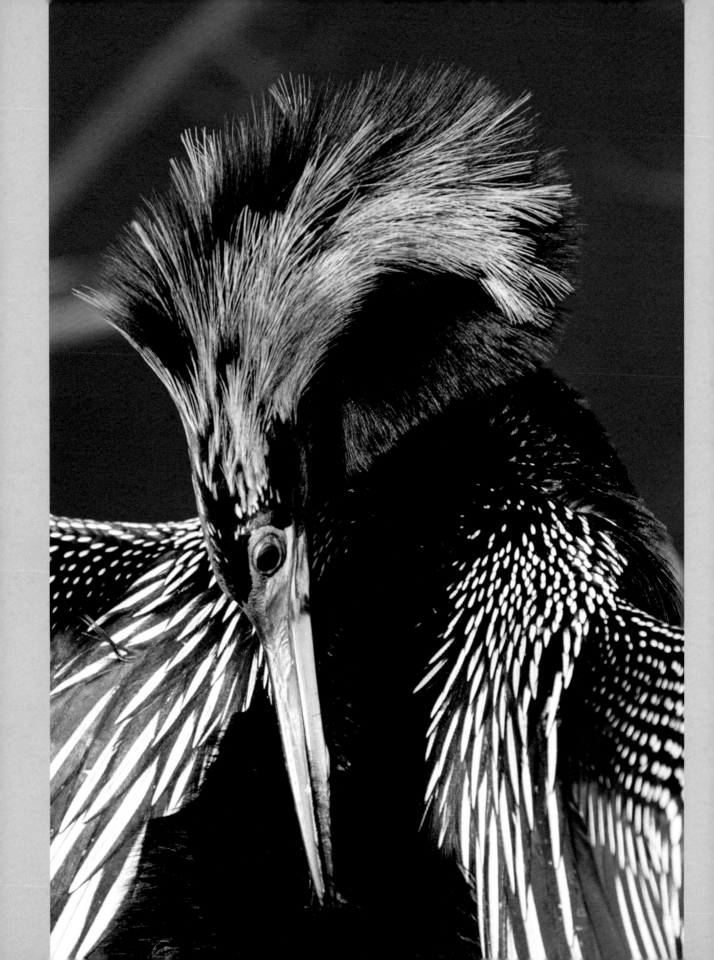

Anhinga

Anhinga Trail, Everglades National Park, FL

In the swamps and marshy lakes of Florida, where the shores are overgrown with rank vegetation and the stately cypress trees are draped with long festoons of Spanish moss, or in the sluggish streams, half choked with water hyacinths, "bonnets" and "water lettuce," where the deadly moccasin lurks concealed in the dense vegetation, where the gayly colored purple gallinules patter over the lily pads and where the beautiful snowy herons and many others of their tribe flourish in their native solitudes, there may we look for these curious birds.

<div align="right">Bent, Petrels, 229</div>

American Oystercatcher

Fort De Soto County Park, Tierra Verde, FL

Few birds, indeed, are more difficult to be approached, and the only means of studying its habits I found to be the use of an excellent telescope, with which I could trace its motions when at the distance of a quarter of a mile, and pursuing its avocations without apprehension of danger. In this manner I have seen it probe the sand to the full length of its bill, knock off limpets from the rocks on the coast of Labrador, using its weapon sideways and insinuating it between the rock and the shell like a chisel, seize the bodies of gaping oysters ...

Audubon, *Birds of America*, 5:237

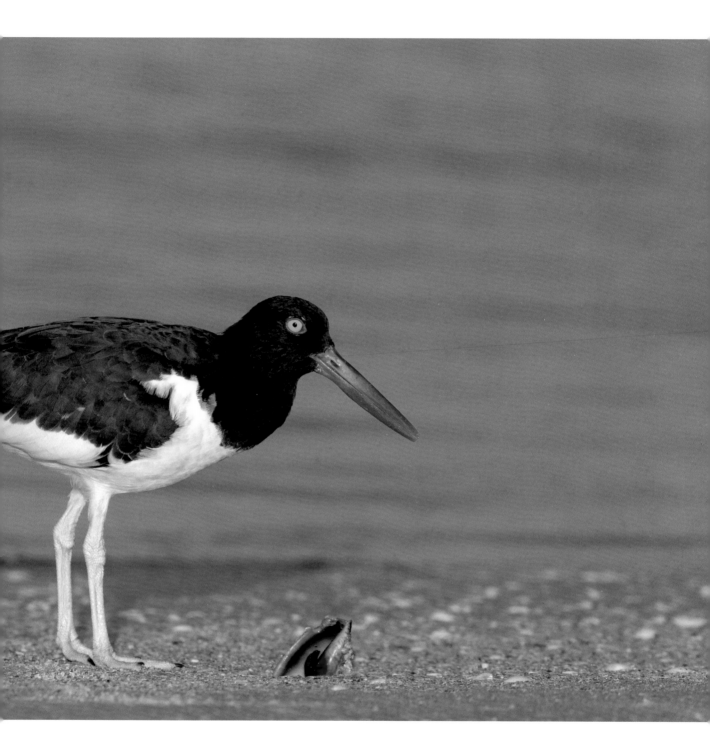

Black Skimmer

Fort De Soto County Park, Tierra Verde, FL

The flight of the Black Skimmer is perhaps more elegant than that of any water bird with which I am acquainted. The great length of its narrow wings, its partially elongated forked tail, its thin body and extremely compressed bill, all appear contrived to assure it that buoyancy of motion which one cannot but admire when he sees it on wing.

Audubon, *Birds of America*, 7:70

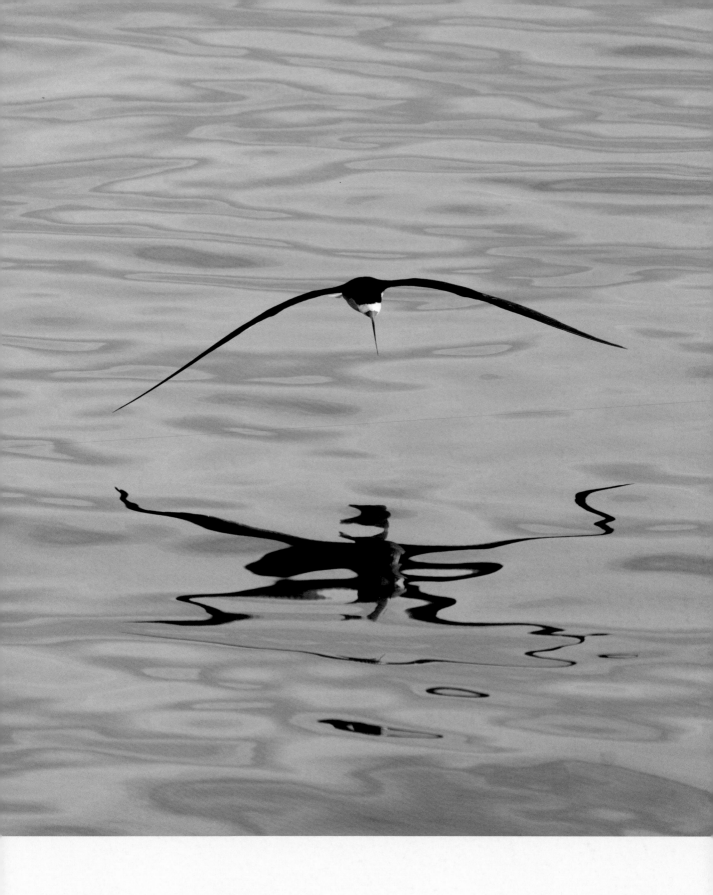

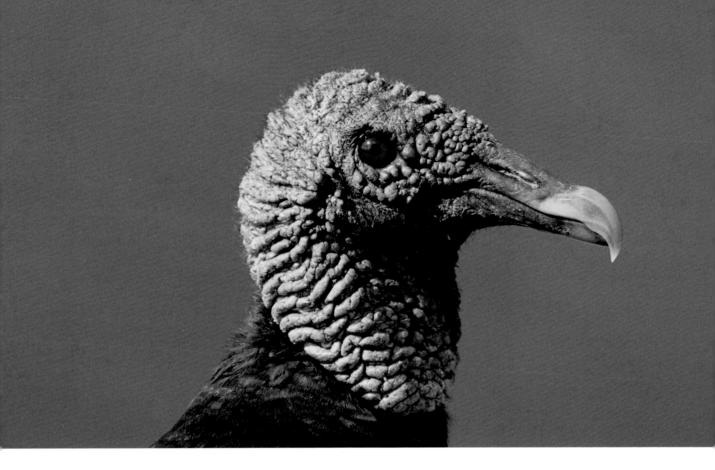

Black Vulture

Anhinga Trail, Everglades National Park, FL

Their head and neck wholly naked, or partially clothed with a woolly down, is small compared with the size of the body, and the latter is frequently long and slender. Although their flight is slow, they can elevate themselves to a prodigious height, ascending and descending in wide spiral circles. Their sight, like that of the Hawks and Eagles, is keen . . .

Nuttall, *Land Birds*, 33–34

Boat-tailed Grackle (*opposite*)

St. Marks National Wildlife Refuge, Wakulla County, FL

Often, in the midst of great activity, the bird will become quite still, then raise its head high, with the beak pointing straight up, neck stretched vertically, and remain so in statuesque immobility for many seconds, sometimes minutes. When several are performing in this way at a time, they present a ludicrous appearance, the wings drooping slightly, the huge tail rigid and every head pointed upward as if they were intent on watching something hundreds of feet above in the sky. Then suddenly, the pose is broken and they return to a vociferous and active pursuit of other antics.

Sprunt, "Eastern Boat-Tailed Grackle," 366

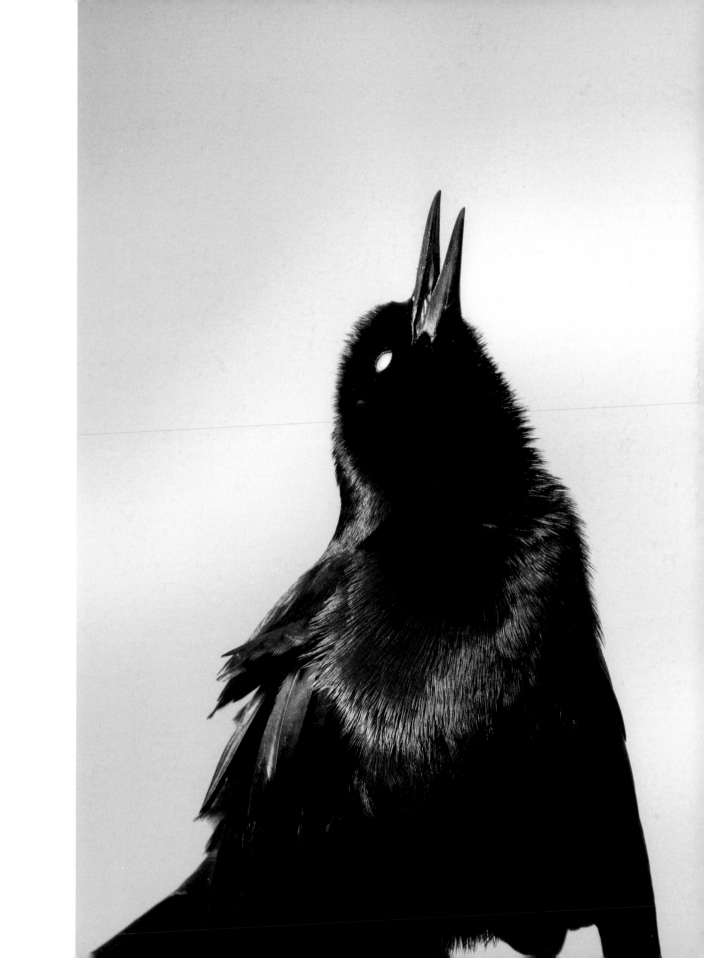

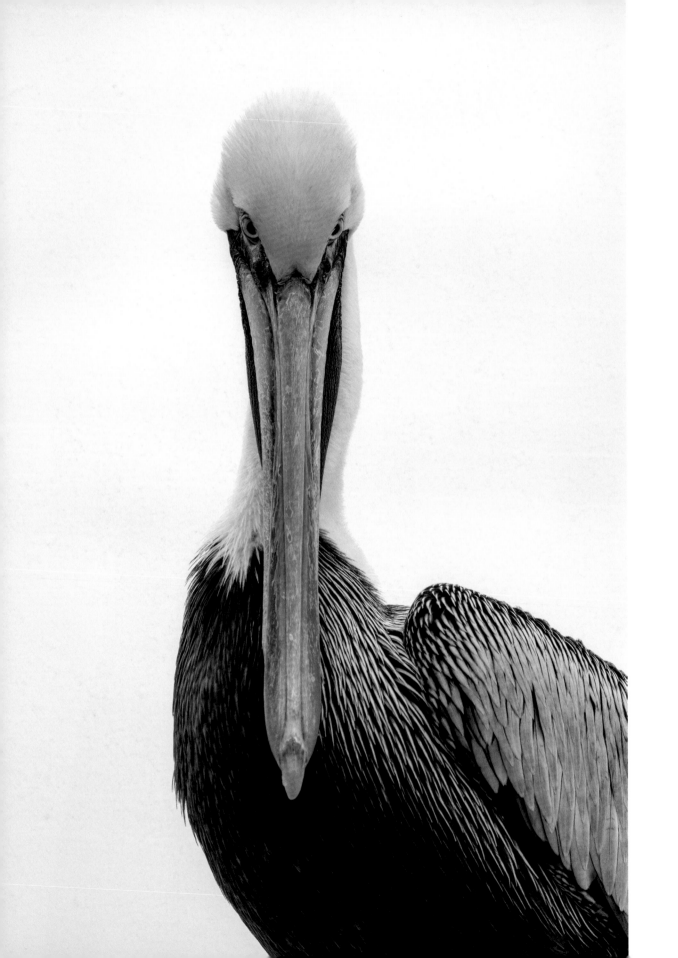

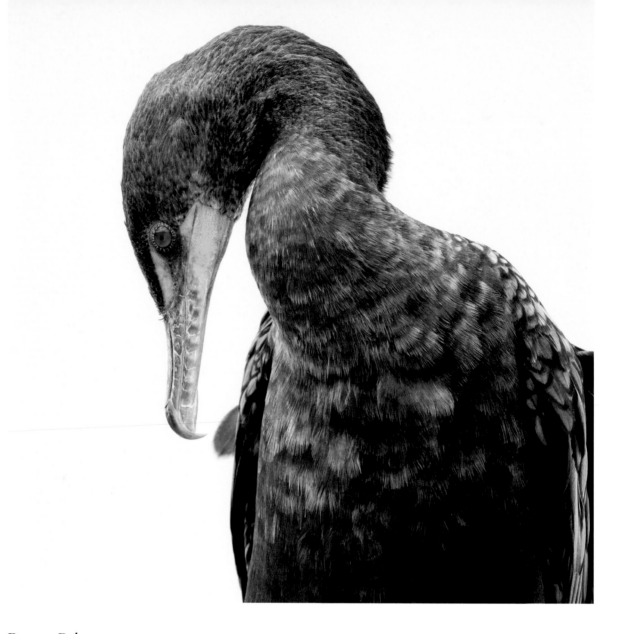

Brown Pelican (*opposite*)

Apalachicola, FL

Double-crested Cormorant

Anhinga Trail, Everglades National Park, FL

There were many thousands of these birds, and each tree bore a greater or less number of their nests, some five or six, others perhaps as many as ten. The leaves, branches, and stems of the trees, were in a manner white-washed with their dung. The temperature in the shade was about 90° Fahr., and the effluvia which impregnated the air of the channels was extremely disagreeable.

Audubon, *Birds of America,* 6:431

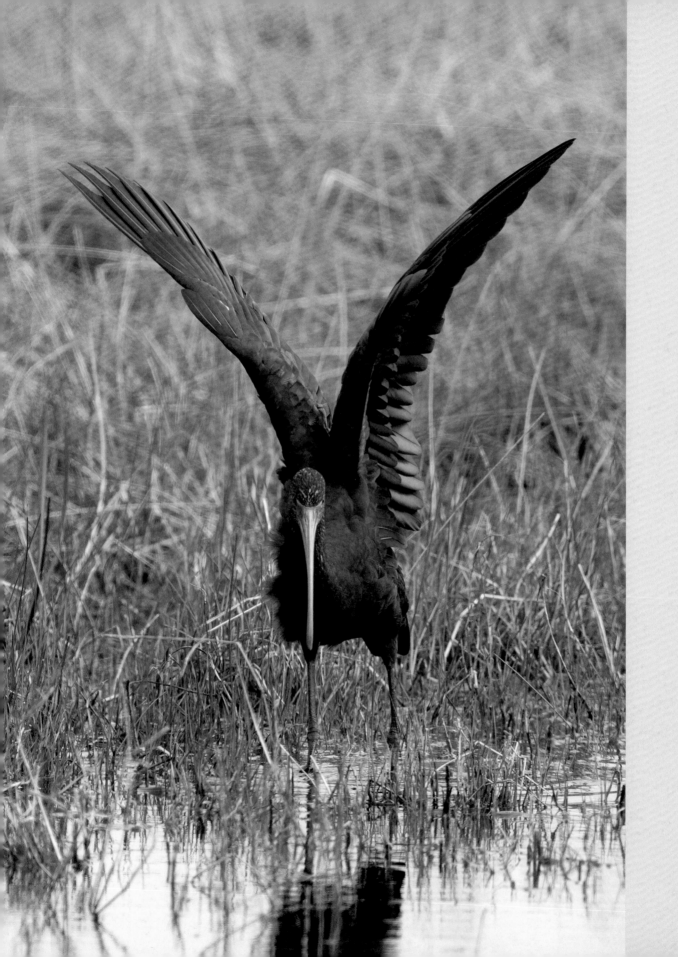

Glossy Ibis

St. Marks National Wildlife Refuge, Wakulla County, FL

The upper part and sides of the head are dark glossy, with purplish reflections. The neck, a portion of the back anteriorly, the breast, abdomen, and legs, are of a deep rich brownish-red or dark chestnut; part of the breast shaded with green, the sides dusky, tinged with green, as are the lower wing-coverts, and lower tail-coverts. Excepting the anterior edge of the wing, and the anterior scapulars, which are deep glossy brownish-red, the upper parts are splendent dark green, glossed with purple; the primaries black, shaded with green; the tail glossy with purple reflections.

Audubon, *Birds of America,* 6:52

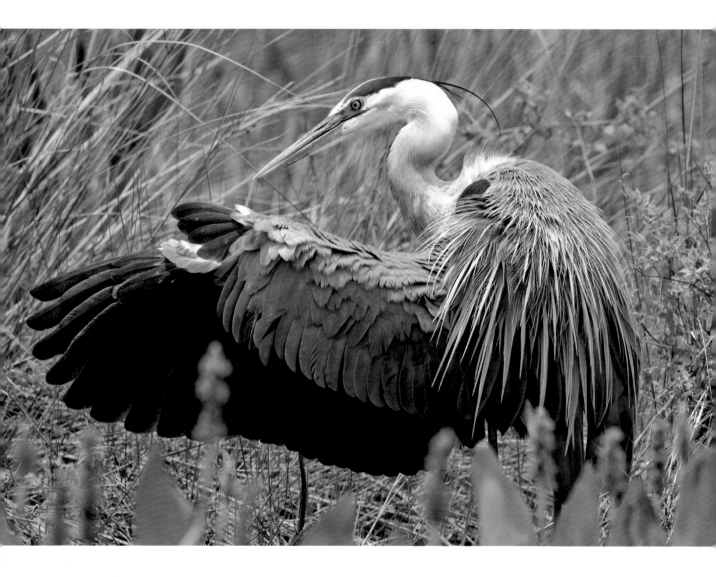

Great Blue Heron

St. Marks National Wildlife Refuge, Wakulla County, FL

It is a stately bird, dignified in its bearing, graceful in its movements and an artistic feature in the landscape.

Bent, *Marsh Birds*, 101

Great Blue Heron

Homosassa Springs Wildlife State Park, Homosassa Springs, FL

. . . bill eight inches long, and one inch and a quarter in width, of a yellow colour, in some blackish on the ridge, extremely sharp at the point, the edges also sharp, and slightly serrated near the extremity; space round the eye from the nostril, a light purplish blue; irides orange, brightening into yellow where they join the pupil; forehead and middle of the crown white, passing over the eye; sides of the crown and hind head deep slate or bluish black, and elegantly crested . . .

Wilson, *American Ornithology*, 3:62

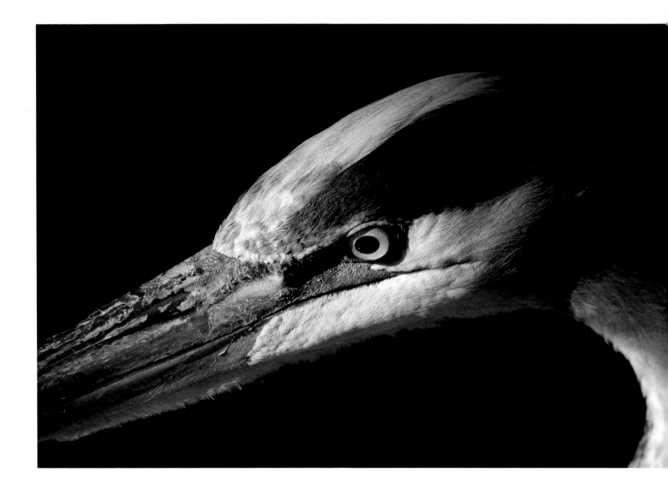

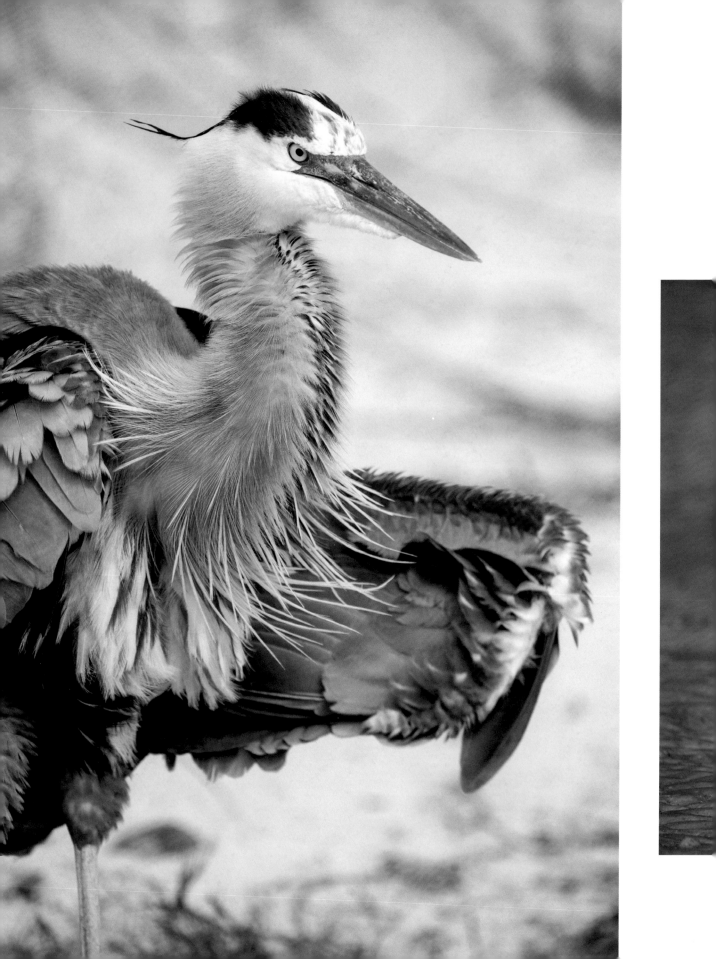

Great Blue Heron (*opposite*)

Fort De Soto County Park, Tierra Verde, FL

Lesser Black-backed Gull

Fort De Soto County Park, Tierra Verde, FL

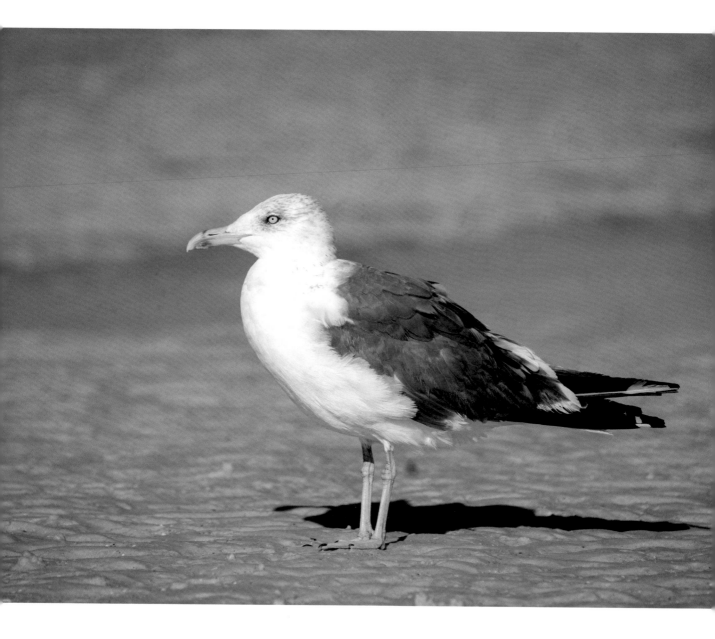

Limpkin

Tallahassee, FL

There is inhabiting the low shores and swamps of this river and the lakes of Florida, as well as Georgia, a very curious bird, called by an Indian name (Ephouskyca) which signifies in our language the crying bird. I cannot determine what genus of European birds to join it with.

Bartram, *Travels*, 145

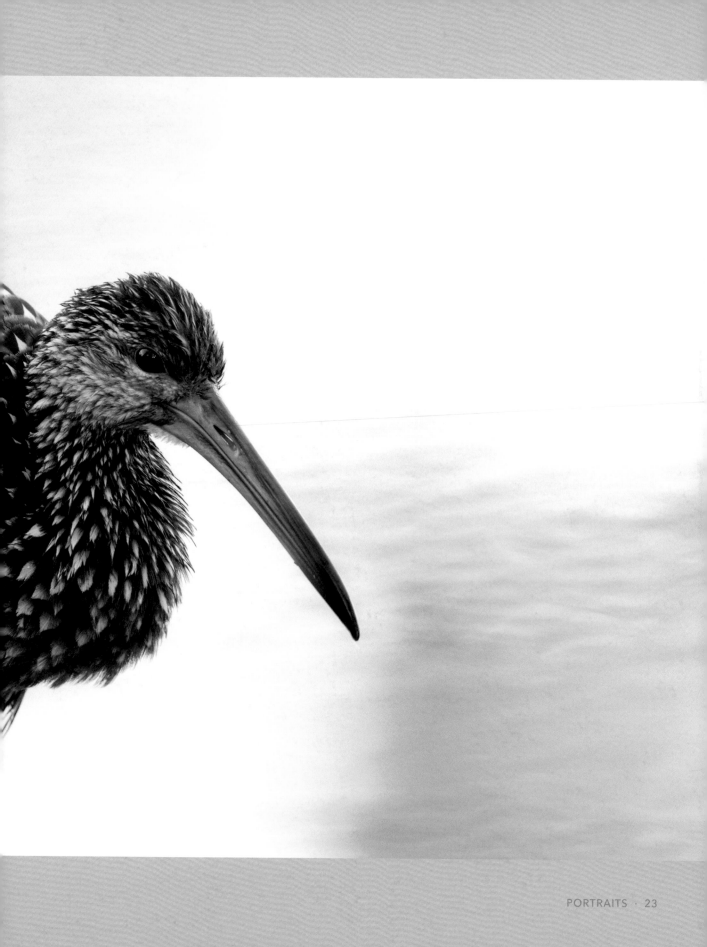

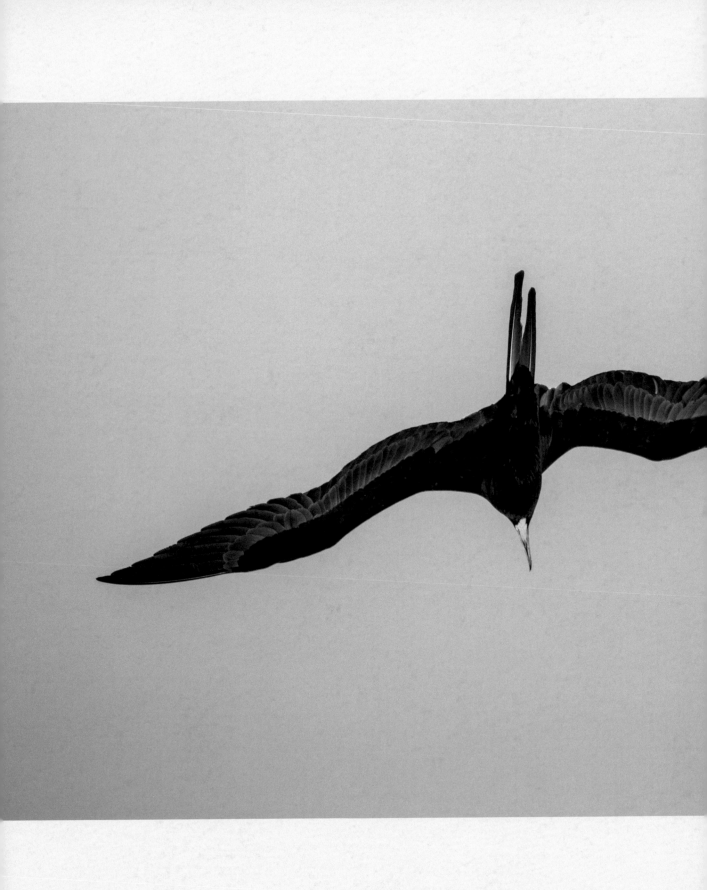

Magnificent Frigatebird

Tierra Verde, FL

The flight of the man-o'-war-bird is an inspiration; the admiring observer is spellbound with wonder as he beholds it and longs for the eloquence to describe it; but words are powerless to convey the impression that it creates. It is the most marvelous and most perfect flying machine that has ever been produced, with 7 or 8 feet of alar expanse, supporting a 4-pound body, steered by a long scissor-like tail. It is not to be wondered at that such an aeroplane can float indefinitely in the lightest breeze.

Bent, *Gallinaceous Birds*, 312

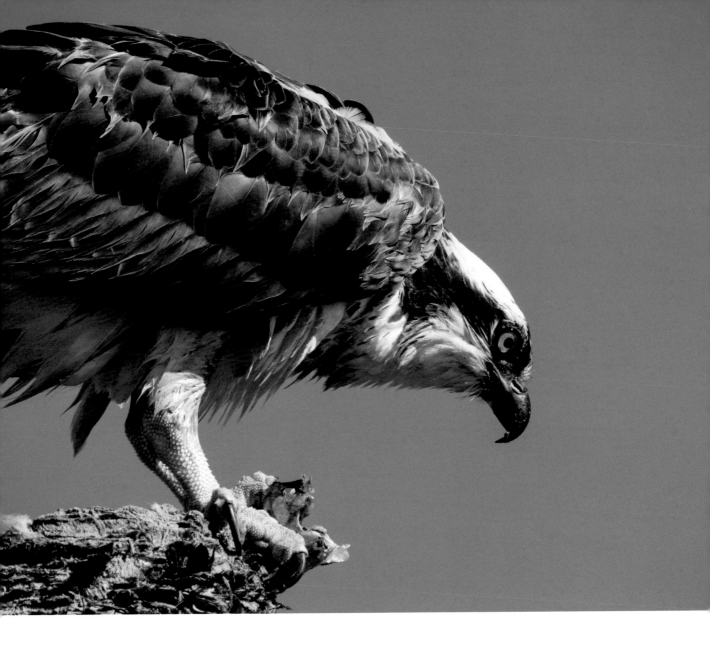

Osprey

St. Marks National Wildlife Refuge, FL

Winging its way slowly over the water, it keeps a keen watch for fish which may appear near the surface. When one is observed it pauses, hovers a moment, and then closing its wings descends with a speed and directness of aim that generally insure success. It strikes the water with great force, making a loud *splash*, and frequently disappears for a moment before rising with its prey grasped in its powerful talons. As a rule, it carries its food to some favorite perch, there to devour it.

Chapman, *Handbook of Birds*, 212

Reddish Egret

Little Estero Lagoon, Estero, FL

The reddish egret in its nuptial display, in which it frequently indulges all through the breeding season to express its emotions, fairly bristles with plumes. The brownish pink plumes of the head, neck, and breast and the bluish gray plumes of the back stand out like the quills of a porcupine giving the bird quite a formidable appearance, terrifying to its enemies, perhaps, but probably pleasing to its mate.

Bent, *Marsh Birds*, 158

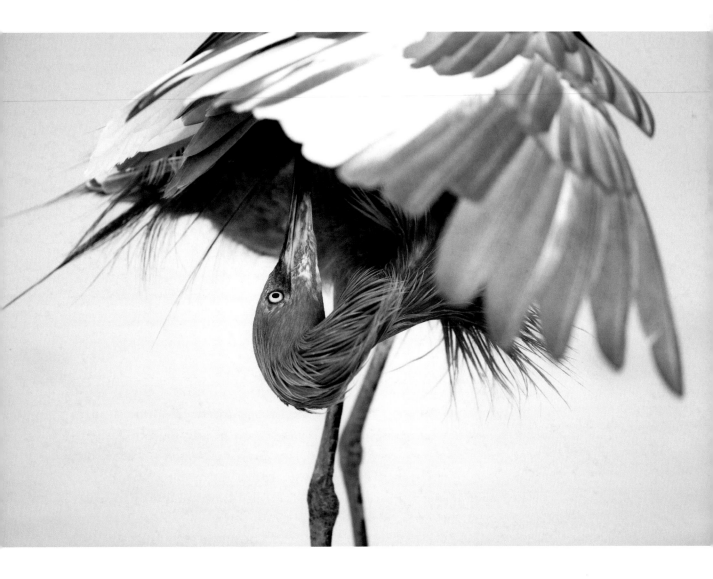

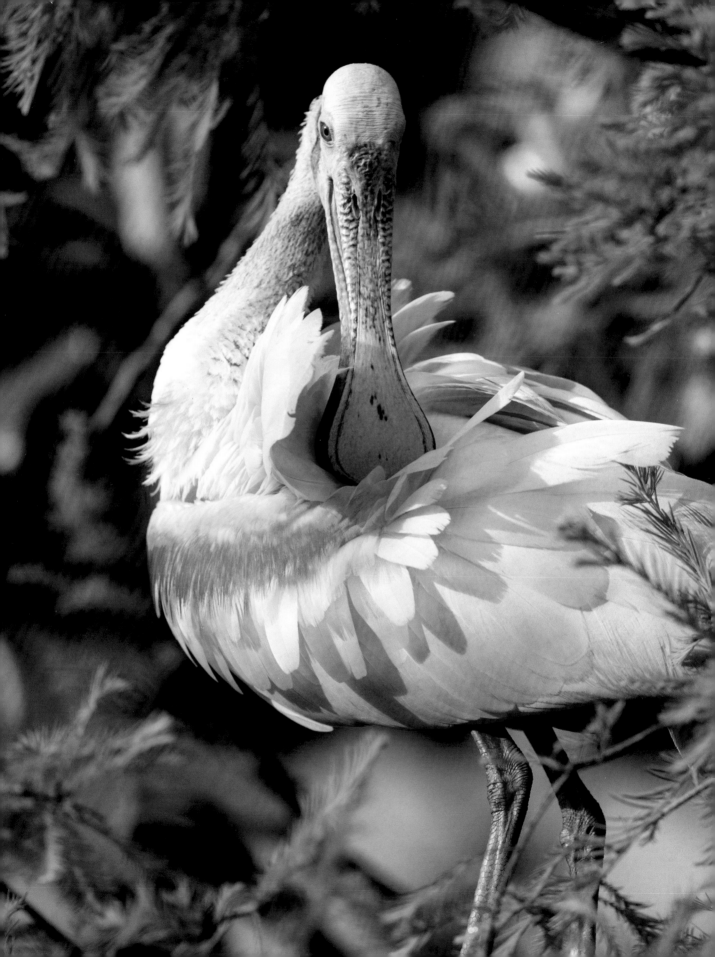

Roseate Spoonbill

St. Augustine Alligator Farm, St. Augustine, FL

In the highest perfection of the adult nuptial plumage there is much rich carmine in the lesser wing coverts and in the upper and lower tail coverts; a bunch of curly carmine feathers adorns the center of the breast, which is also suffused with pink and with "ochraceous buff"; sometimes the neck is mottled with a few carmine feathers; and the tail is a rich "ochraceous buff."

Bent, *Marsh Birds*, 18

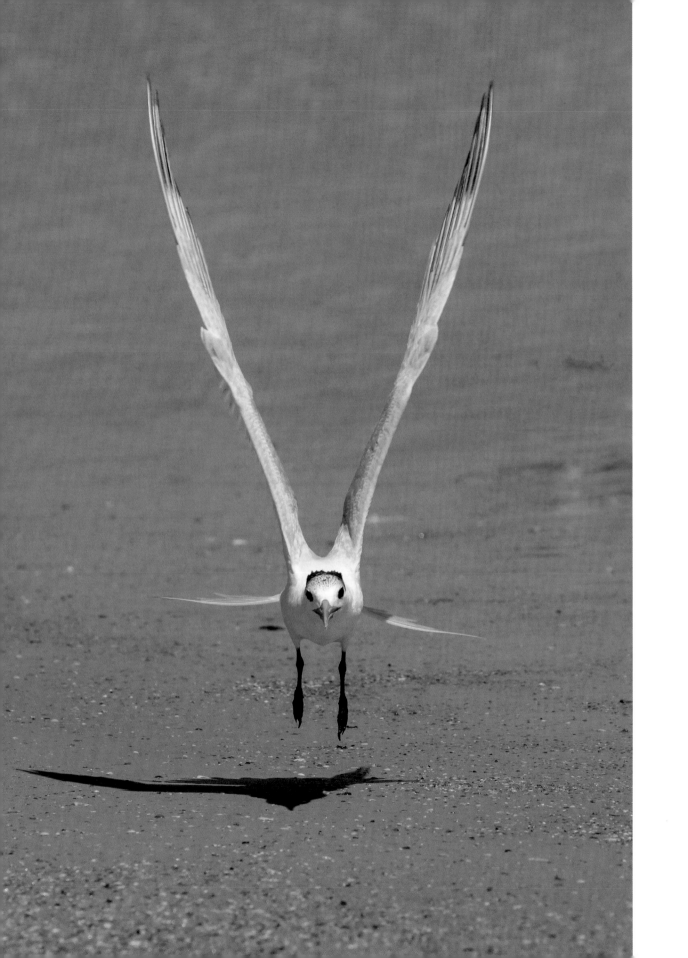

Royal Tern (*opposite*)

Huguenot Memorial Park, Jacksonville, FL

Although the Cayenne [Royal] Tern often searches for food over the sea, and at times several miles from the shore, it gives a decided preference to the large inlets running parallel to the coast of the Floridas, within the high sandy embankments, as well as the rivers in the interior of the peninsula.

<div align="right">

Audubon, *Birds of America*, 7:77

</div>

Ruddy Turnstone

Fort De Soto County Park, Tierra Verde, FL

. . . they are almost entirely maritime, following the retreating waves, and gleaning at the ebb of the tide, the various marine insects, and small shell-fish, which constitute their food. As may be supposed, from their name, they have a peculiar habit of dexterously turning over considerable stones with their bills, in quest of their insect prey.

<div align="right">

Nuttall, *Water Birds*, 29

</div>

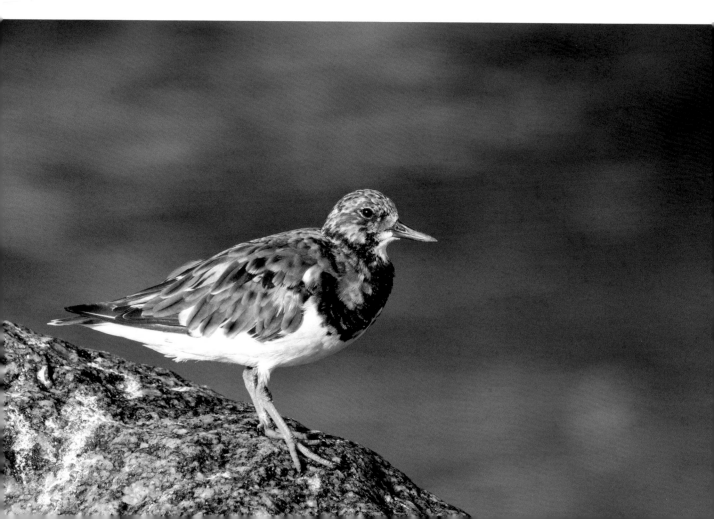

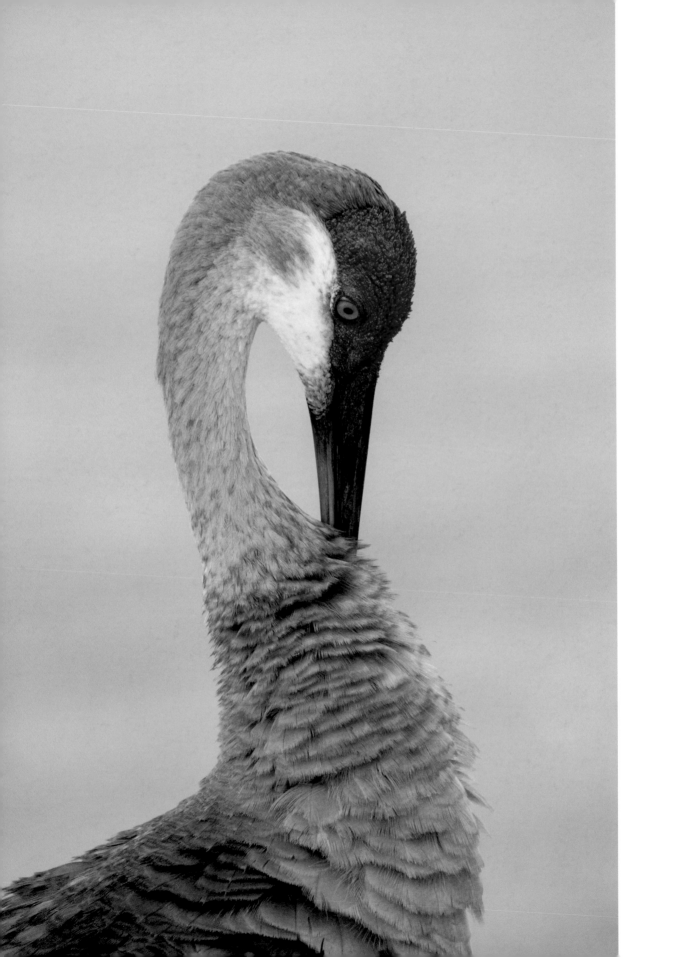

Sandhill Crane (*opposite*)

East Lake Tohopekaliga, Kissimmee, FL

For half an hour or so, they usually dress their plumage, standing erect . . .

Audubon, *Birds of America*, 5:191

Sandhill Crane

Homosassa Springs Wildlife State Park, Homosassa Springs, FL

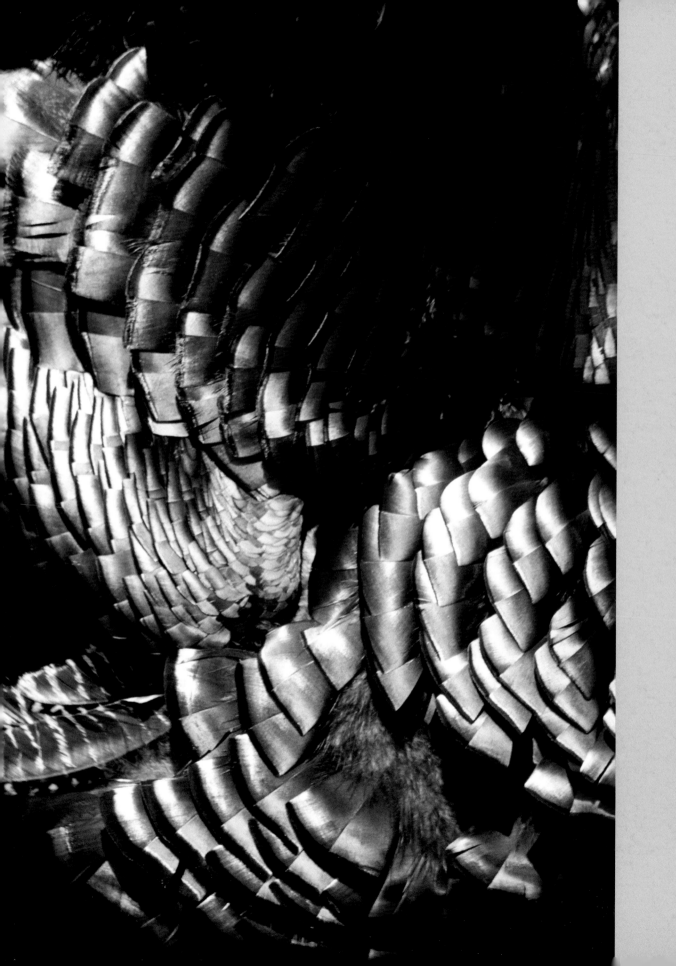

Wild Turkey

Homosassa Springs Wildlife State Park, Homosassa Springs, FL

Having rested very well during the night, I was awakened in the morning early, by the cheering converse of the wild turkey-cocks. . . . They begin at early dawn, and continue till sun-rise, from March to the last of April. The high forests ring with the noise, like the crowing of the domestic cock, of these social centinels; the watch-word being caught and repeated, from one to another, for hundreds of miles around; insomuch that the whole country is for an hour or more in an universal shout.

Bartram, *Travels*, 81–82

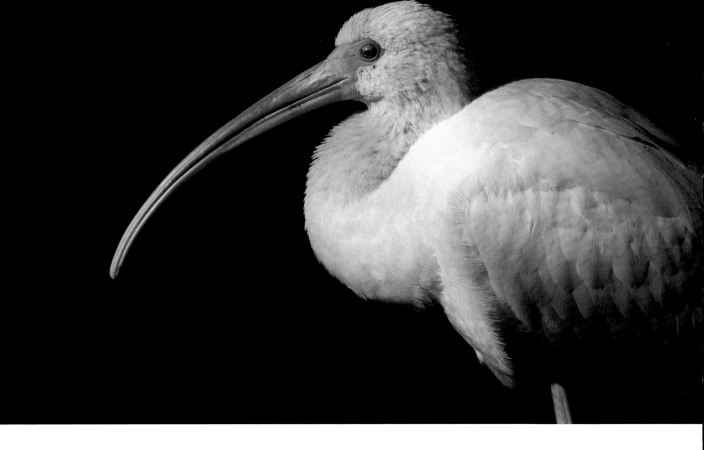

White Ibis

Homosassa Springs Wildlife State Park, Homosassa Springs, FL

Wood Stork (*opposite*)

Homosassa Springs Wildlife State Park, Homosassa Springs, FL

The carriage of the wood ibis [stork] is firm and sedate, almost stately; each leg is slowly lifted and planted with deliberate precision, before the other is moved, when the birds walk unsuspicious of danger. I never saw one run rapidly, since on all occasions when I have been the cause of alarm, the bird took wing directly. It springs powerfully from the ground, bending low to gather strength, and for a little distance flaps hurriedly with dangling legs, as if it was much exertion to lift so heavy a body.

Coues, *Birds of the North West*, 516 (quoted in Bent, *Marsh Birds*, 63)

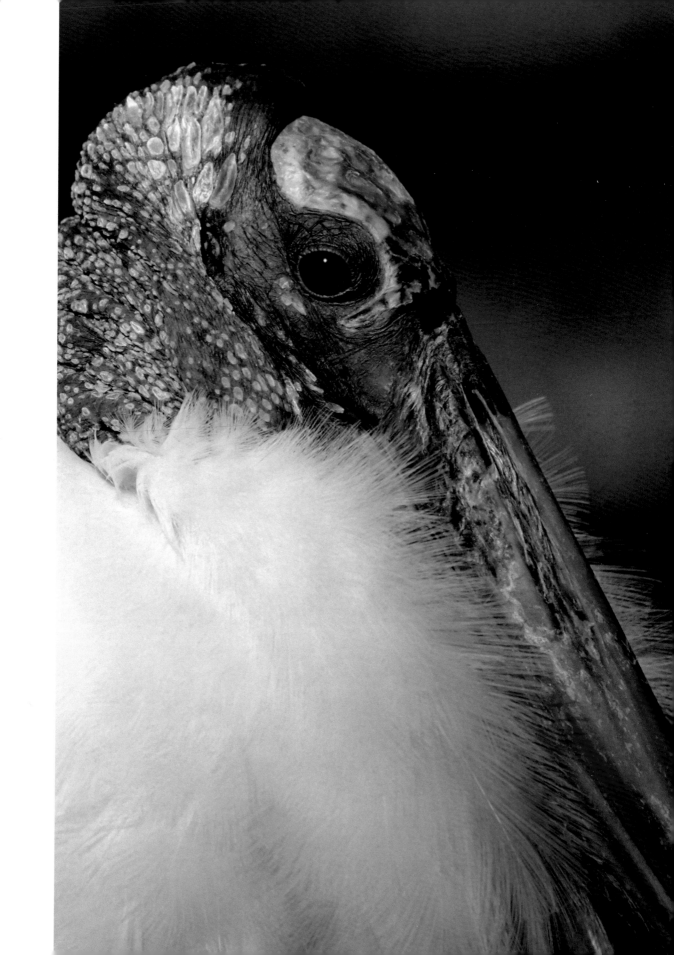

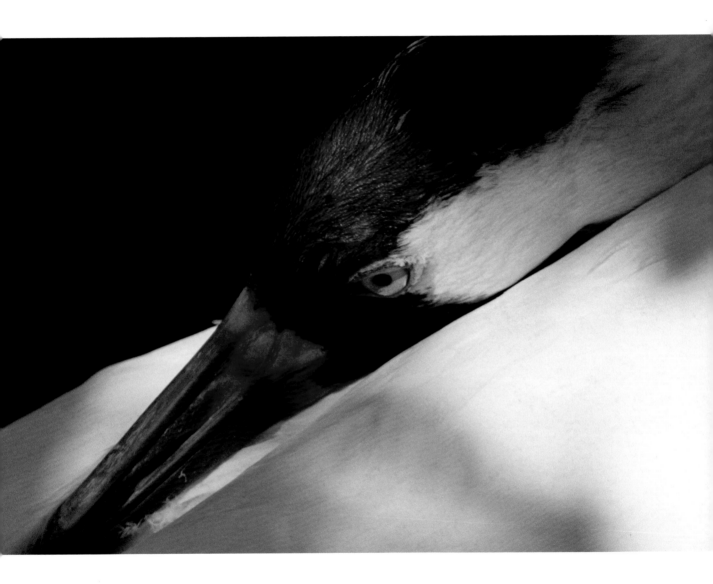

Whooping Crane

Homosassa Springs Wildlife State Park, Homosassa Springs, FL

This magnificent species, one of the grandest and most striking of North American birds, is supposed to be on the verge of extinction. In its former abundance, its great migration flights, its curious conventions, in which it indulged in grotesque dances, and its interesting aerial evolutions must have formed some of the most spectacular performances in American ornithology.

Bent, *Marsh Birds*, 219

ON THE WING

Black Skimmer

Fort De Soto County Park, Tierra Verde, FL

In flight the black skimmer is one of the most graceful of sea birds and the most highly specialized. Its slender build, its long, powerful wings and its broad forked tail are perfectly adapted to its modes of life. The strongest winds offer but little resistance to the little ball of feathers, supported by two long, slender blades which cut the air like the keenest razor. It has a strong combination of buoyancy and strength; it is swift and skillful on the wing, and always holds itself in perfect control. When flying in a flock, as is customary, its movements are synchronous to a high degree of perfection, the whole flock twisting, turning, wheeling, rising, or falling in perfect unison.

Bent, *Gulls*, 316

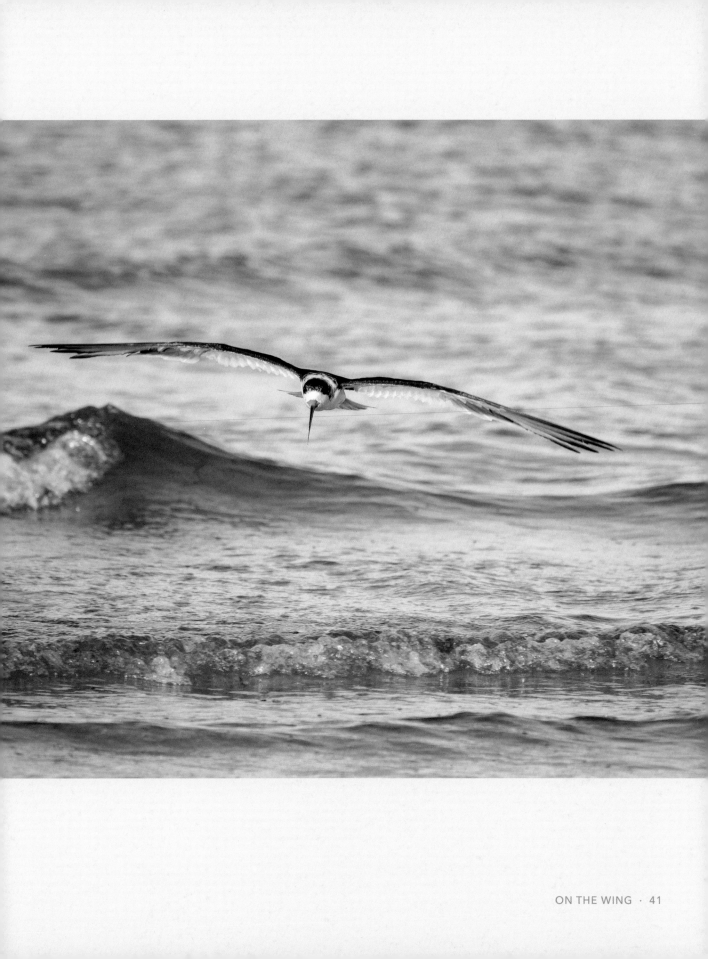

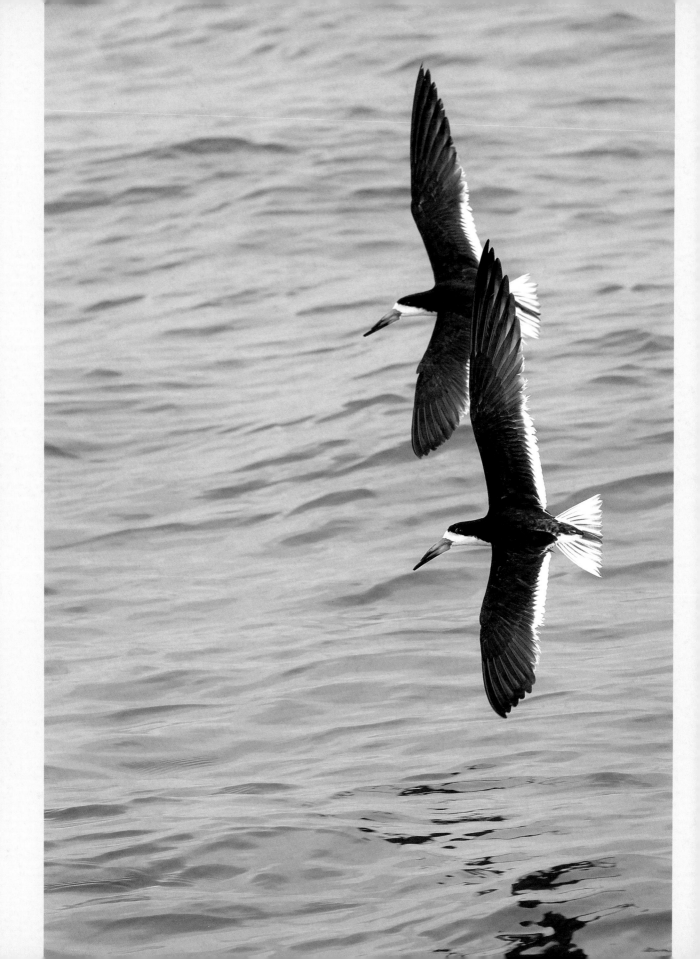

Black Skimmer

Fort De Soto County Park, Tierra Verde, FL

 To all these is added a vast expansion of wing, to enable the bird to sail with
sufficient celerity while dipping in the water. The general proportion of the length
of our swiftest Hawks and Swallows, to their breadth, is as one to two; but in the
present case, as there is not only the resistance of the air, but also that of the water, to
overcome, a still greater volume of wing is given . . .

<div align="right">Wilson, American Ornithology, 3:236–237</div>

Brown Pelican

Fort De Soto County Park, Tierra Verde, FL

The flight of the Brown Pelican, though to appearance heavy, is remarkably well sustained, that bird being able not only to remain many hours at a time on wing, but also to mount to a great height in the air to perform its beautiful evolutions.

Audubon, *Birds of America,* 7:33

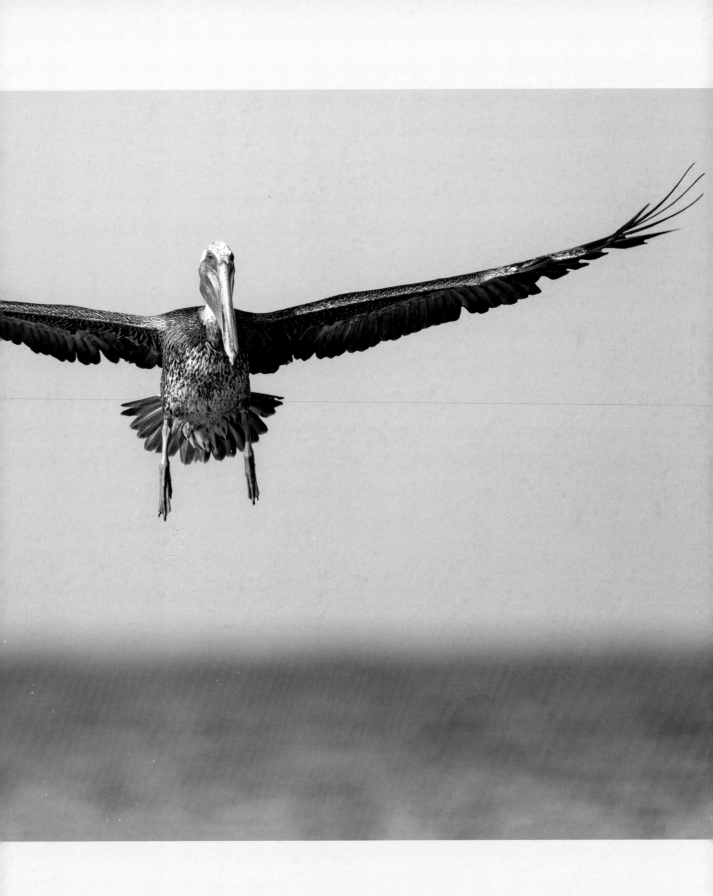

Great Egret

St. Augustine Alligator Farm, St. Augustine, FL

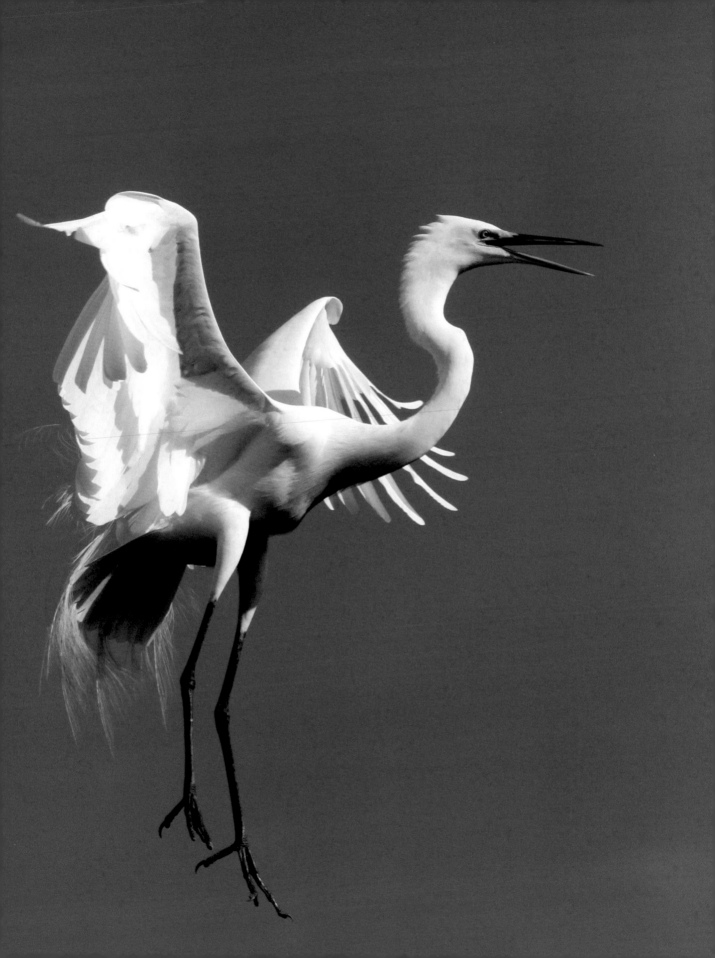

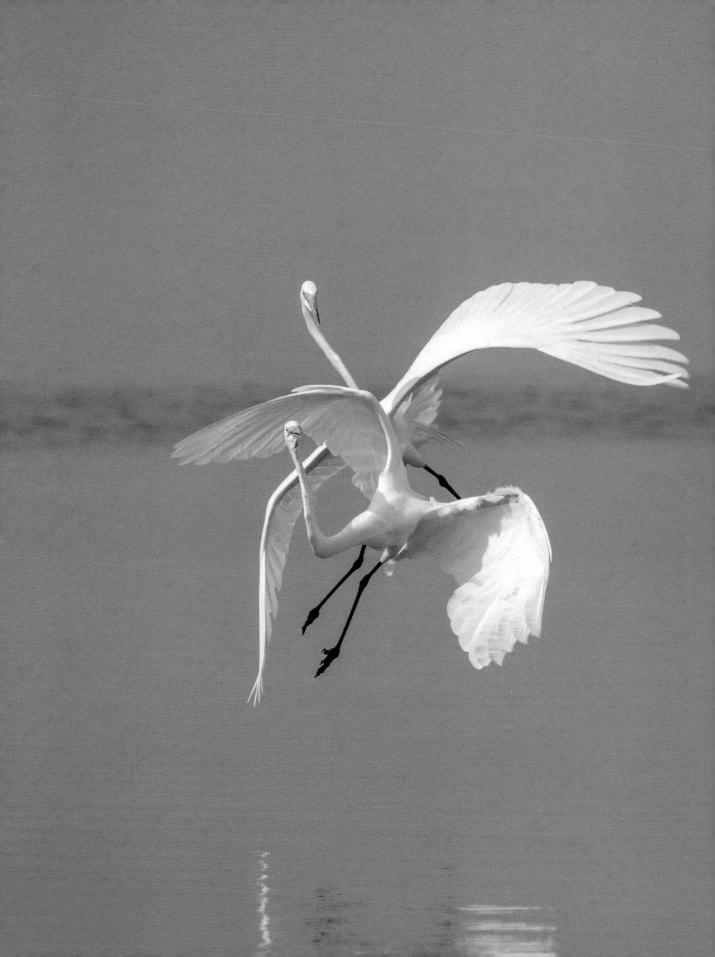

Great Egrets

Fort De Soto County Park, Tierra Verde, FL

The pose of the American egret in flight is not unlike that of the other herons; when well under way it carries its neck folded backward, with its head between its shoulders, and its long legs extended behind it as a rudder. But it seems to me that it is easily recognized at even a great distance by its more slender form and by its proportionately longer and broader wings . . .

Bent, *Marsh Birds*, 140

Laughing Gull

Fort De Soto County Park, Tierra Verde, FL

[T]he zealous inquirer would find himself amply compensated for all his toil, by observing these neat and clean birds coursing along the rivers and coast, enlivening the prospect by their airy movements: now skimming closely over the watery element, watching the motions of the surges, and now rising into the higher regions, sporting with the winds; while he inhaled the invigorating breezes of the ocean, and listened to the soothing murmurs of its billows.

Wilson, *American Ornithology*, 3:254

Magnificent Frigatebird

Tierra Verde, FL

The Frigate Bird is often seen smoothly gliding through the air, with the motions of a Kite, from one to two hundred leagues from the land, sustaining these vast flights with the greatest apparent ease, sometimes soaring so high as to be scarcely visible, at others approaching the surface of the sea, where hovering at some distance, it at length espies a fish, and darts upon it with the utmost rapidity and generally with success, flying upwards again, as quick as it descended.

Nuttall, *Water Birds*, 492

Osprey

St. Marks National Wildlife Refuge, FL

Whilst in search of food, it flies with easy flappings at a moderate height above the water, and with an apparent listlessness, although in reality it is keenly observing the objects beneath. No sooner does it spy a fish suited to its taste, than it checks its course with a sudden shake of its wings and tail, which gives it the appearance of being poised in the air for a moment, after which it plunges headlong with great rapidity into the water, to secure its prey, or continues its flight, if disappointed by having observed the fish sink deeper.

Audubon, *Birds of America,* 1:66

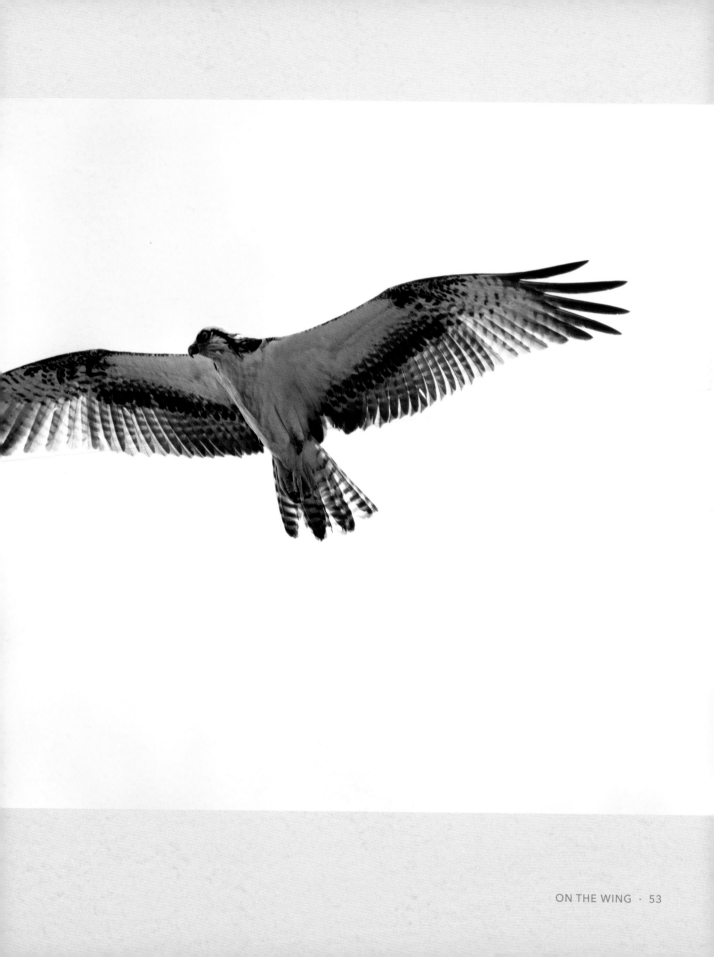

Roseate Spoonbill

St. Marks National Wildlife Refuge, Panacea, FL

[S]uddenly, with a *woof-woof-woof* of wings six Spoonbills lit up my foreground. One of them perched within fifteen feet of me. Other Spoonbills flew overhead, evidently reconnoitering, and it was when seen against the intense blue of the zenith that their peach-blossom color appeared to take its deepest hue.

Chapman, *Camps and Cruises*, 146

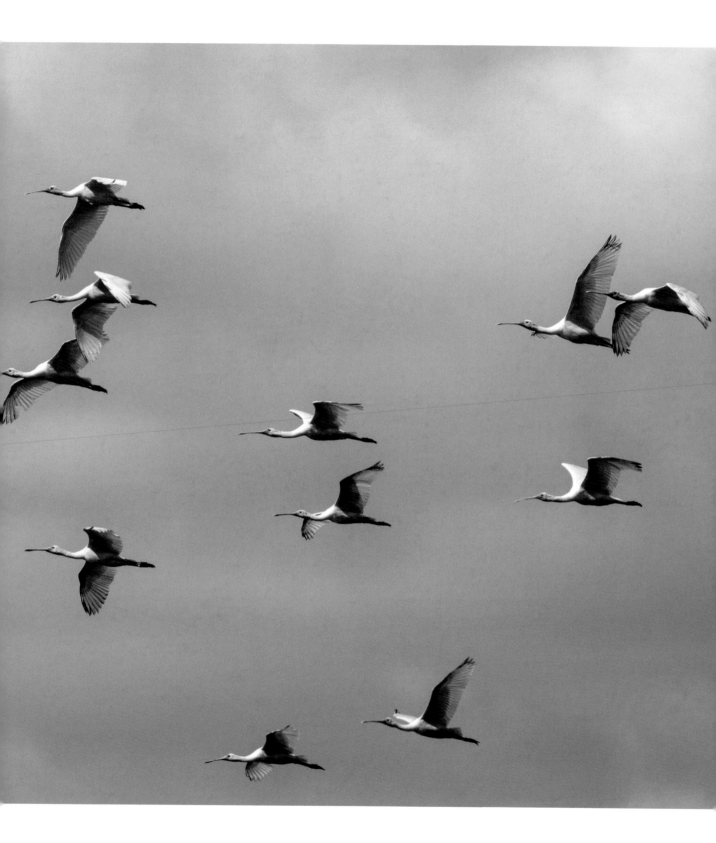

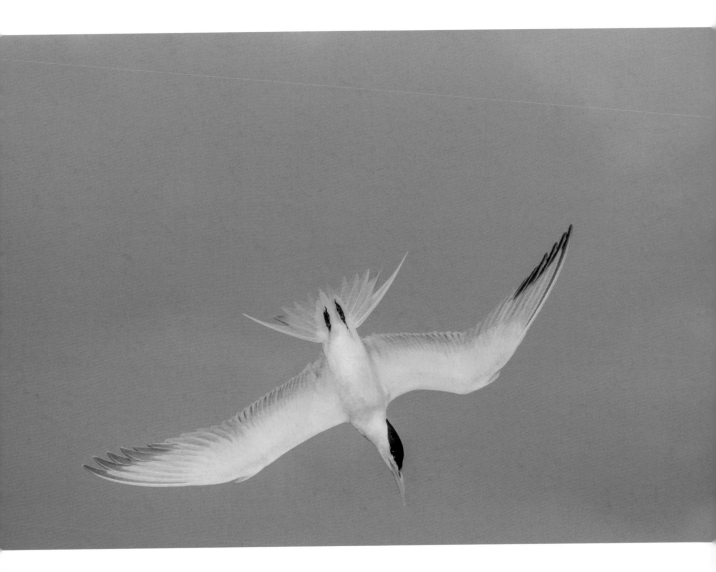

Royal Tern

Fort De Soto County Park, Tierra Verde, FL

Presently he again stops short, flutters; then bringing the elbow of the wings to a right angle, descends perpendicularly, but with a singular turning of the body, so as to present now the back, now the belly, alternately, to the observer; not, however, by a rotation, but irregularly, and as if by jerks. But his purpose is again frustrated for on nearly reaching the surface he recovers himself with a graceful sweep and remounts on flagging wing.

Gosse, *Birds of Jamaica*, 432 (quoted in Bent, *Gulls*, 217)

Royal Tern

Fort De Soto County Park, Tierra Verde, FL

Head and body shake in flight to dry off after bathing.

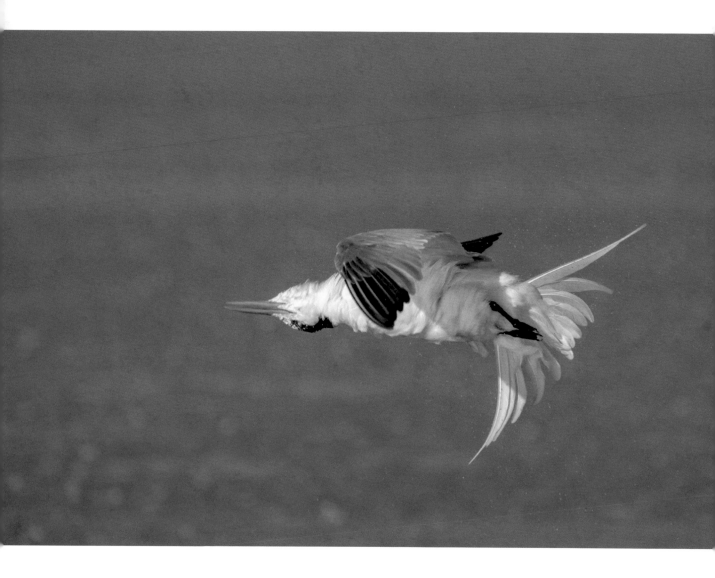

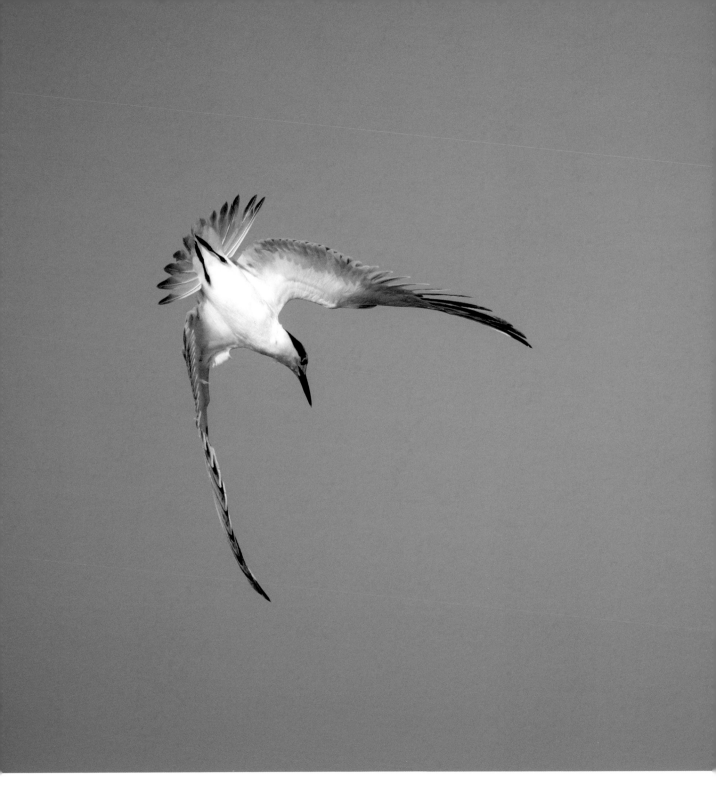

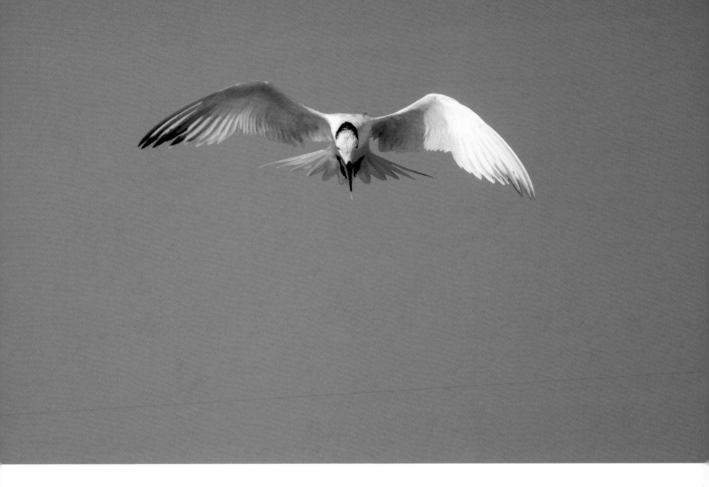

Sandwich Tern (*opposite*)

Fort De Soto County Park, Tierra Verde, FL

Should the fish disappear, as the bird is descending, the latter instantly recovers itself without plunging into the water. Its cries are sharp, grating, and loud enough to be heard at the distance of half a mile.

Audubon, *Birds of America,* 7:88

Sandwich Tern

Fort De Soto County Park, Tierra Verde, FL

While plunging after the small mullets and other diminutive fishes that form the principal part of its food, it darts perpendicularly downwards with all the agility and force of the Common and Arctic Terns, nearly immersing its whole body at times, but rising instantly after, and quickly regaining a position from which it can advantageously descend anew.

Audubon, *Birds of America,* 7:87–88

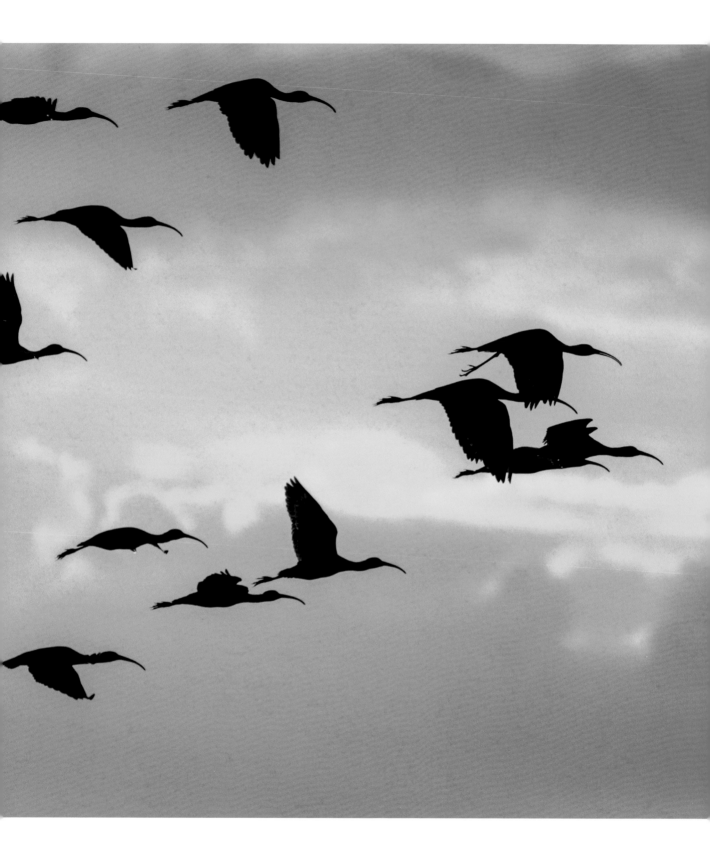

White Ibis

East Lake Tohopekaliga, Narcoossee, FL

It was a joy to watch the graceful aerial evolutions of the stately wood ibises and to mark the morning and evening flights of the white ibises between their feeding ground and their rookeries in distant swampy thickets. Sometimes in large, loose flocks and sometimes in long, straggling lines, they were always recognizable by their snowy whiteness and their rapid wing beats.

Bent, *Marsh Birds*, 23

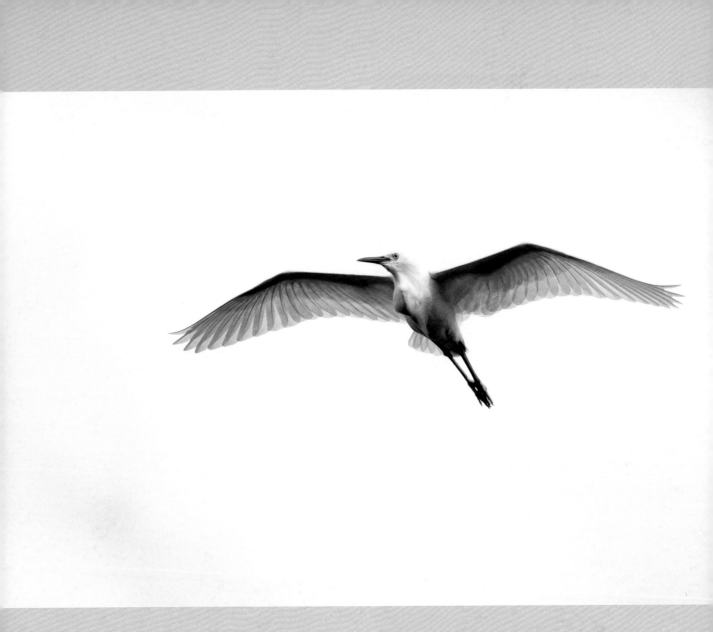

Snowy Egret

St. Augustine Alligator Farm, St. Augustine, FL

FEEDING

Black-crowned Night Heron

St. Marks National Wildlife Refuge, FL

They are awkward and ludicrous in appearance, but they are usually quite successful in their efforts and more expert at climbing than they appear to be. They make good use of all five of their extremities in climbing, clinging with their feet, supporting themselves on their wings, hooking the neck over a branch or seizing it with the bill. I have seen one do what we used to call the "giant swing," clinging to a branch with bill and feet.

Bent, *Marsh Birds*, 204–205

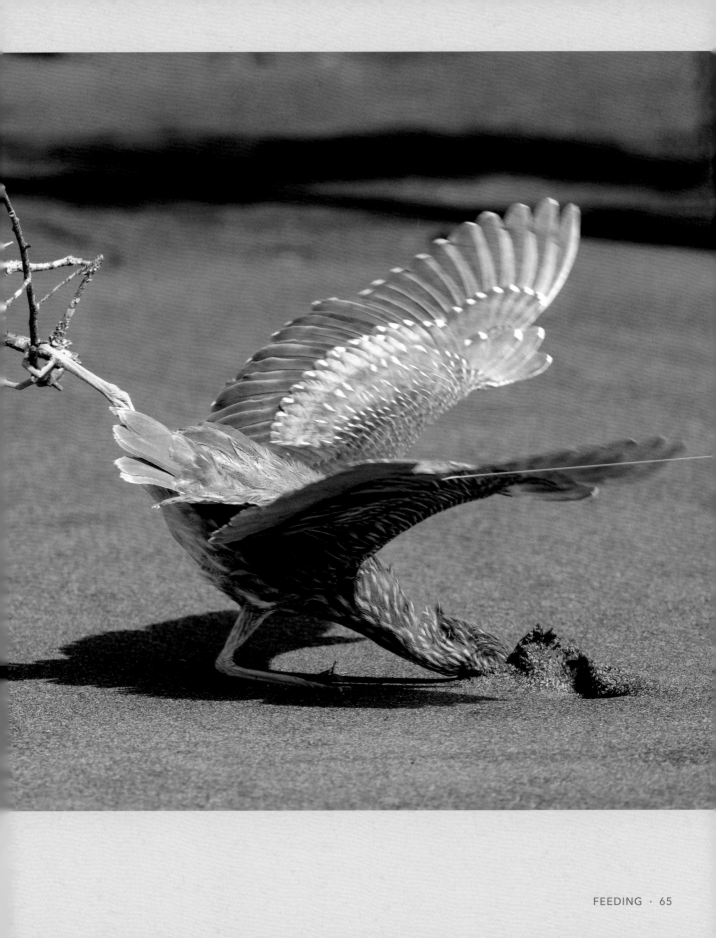

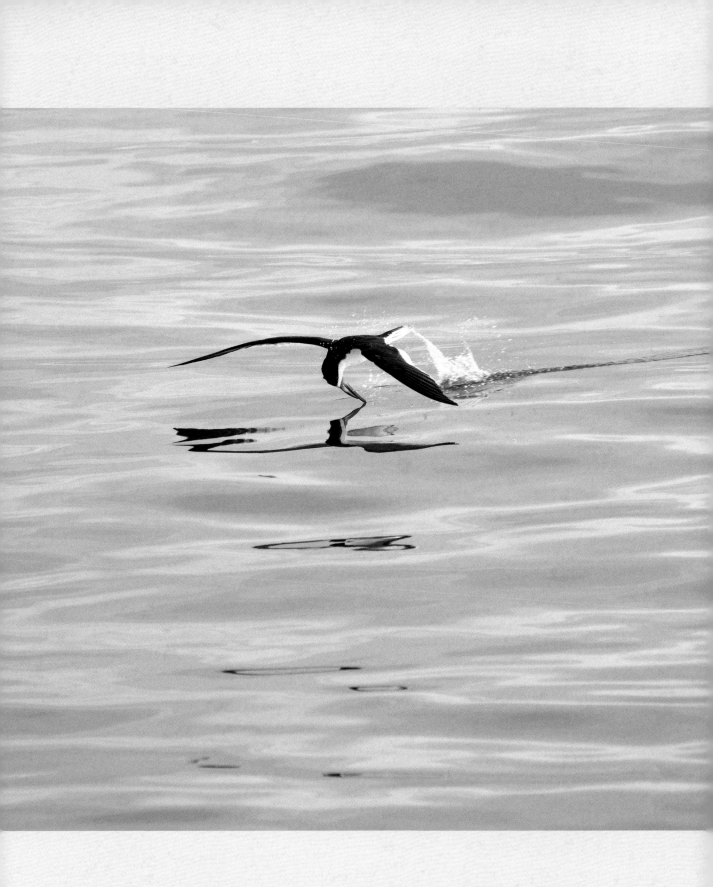

Black Skimmer

Fort De Soto County Park, Tierra Verde, FL

So singular in form is the bill of the adult Skimmer, that Buffon described it as an "awkward and defective instrument." ... With the lower mandible averaging half an inch longer than the upper, and with both so thin and flexible that they can be bent as readily as a table knife, one might be pardoned for believing the Skimmer's bill a deformity; but the belief is quickly dispelled when once the bird is seen feeding. Flying low, with bill opened wide, the lower mandible cuts the water like a knife edge, as the birds actually skim the surface for fish and small forms of aquatic life.

Chapman, *Camps and Cruises*, 72–73

Brown Pelican

Fort De Soto County Park, Tierra Verde, FL

A flock will leave their resting place, proceed over the waters in search of fish, and when a shoal is perceived, separate at once, when each, from an elevation of from fifteen to twenty-five feet, plunges in an oblique and somewhat winding direction, spreading to the full stretch its lower mandible and pouch, as it reaches the water, and suddenly scoops up the object of its pursuit . . . sometimes plunging eight or ten times in a few minutes, and always with unerring aim.

Audubon, *Birds of America,* 7:35

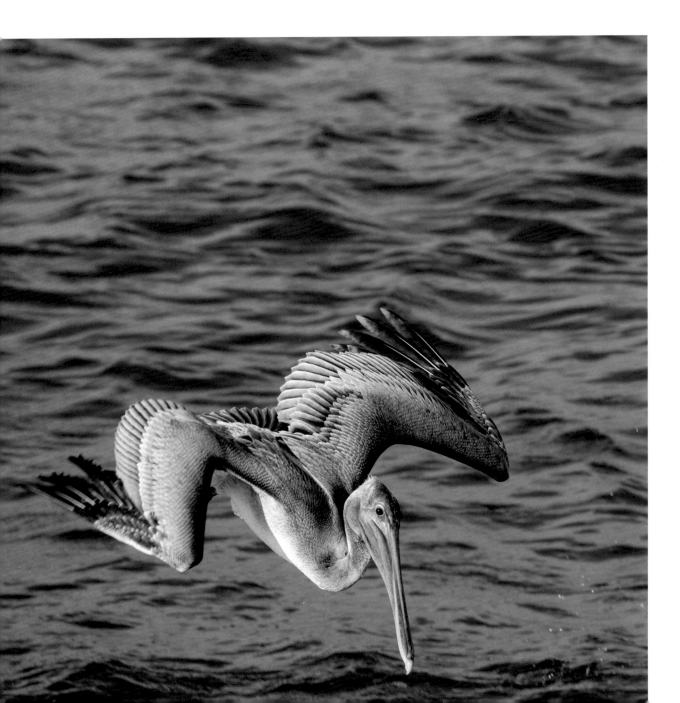

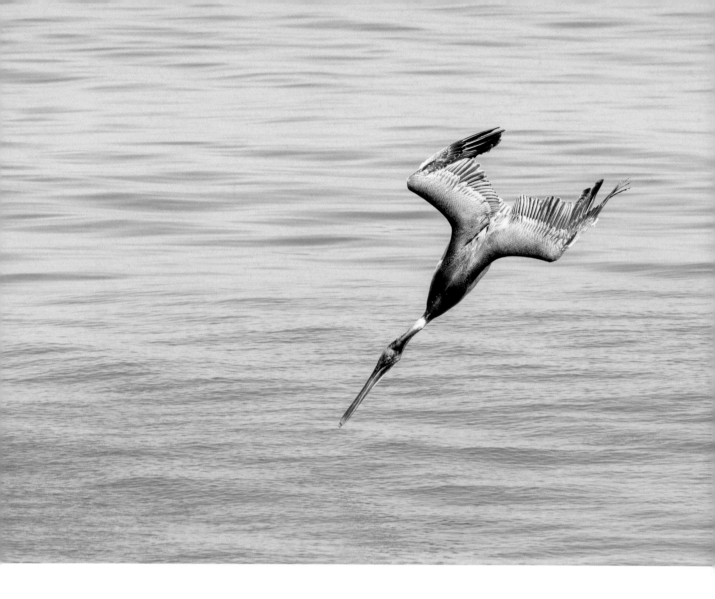

Brown Pelican

Bonita Beach, FL

As it thrusts its neck down, its wings are three-quarters closed and extended backward as far as possible, thus throwing the center of gravity in front of any wing support, and the following wind instantly catches in the partly closed wing tips and completes the inversion, then by deft manipulation of its almost closed wings, it maintains its perpendicular position as it volplanes downward.

Nichols, *Bird Notes*, 21

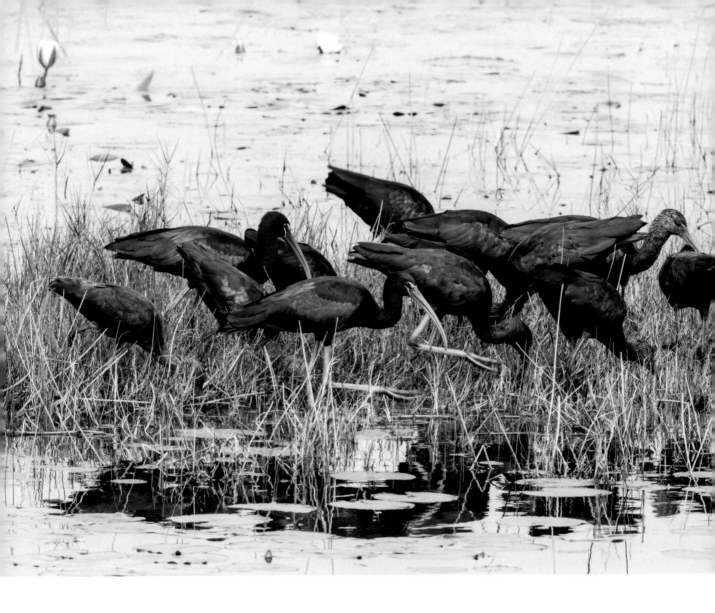

Glossy Ibis and White-faced Ibis

St. Marks National Wildlife Refuge, FL

The Ibises ordinarily dwell together in flocks, in marshy and inundated grounds, exploring for their food with great regularity, side by side advancing, like disciplined troops in an extended line, perambulating the meadows they visit in preference to making a desultory flight, and for hours they are observed boring the same spot with their long and sensitive bills, when their prey is abundant.

Nuttall, *Water Birds*, 89

Great Egret (*opposite*)

Fort De Soto County Park, Tierra Verde, FL

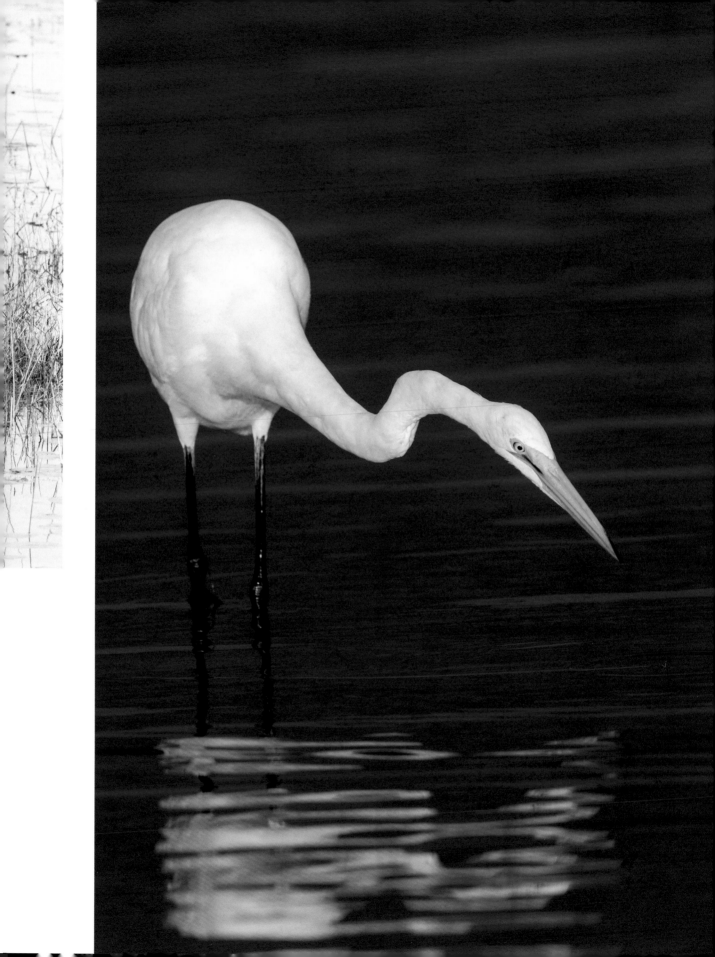

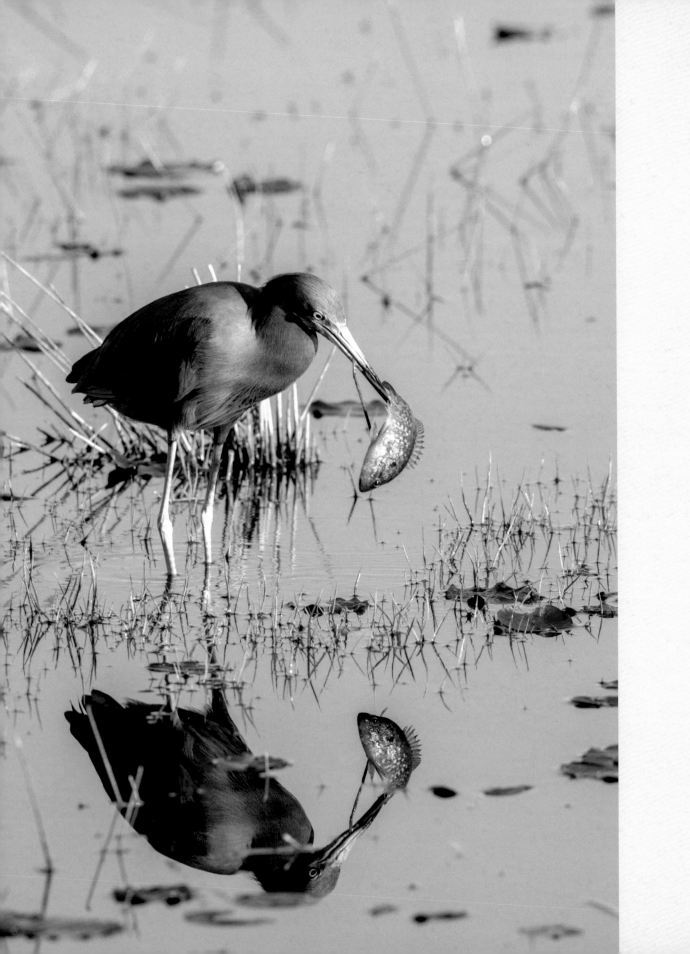

Little Blue Heron

St. Marks National Wildlife Refuge, FL

[Y]ou may see this graceful Heron, quietly and in silence walking along the margins of the water, with an elegance and grace which can never fail to please you. Each regularly-timed step is lightly measured, while the keen eye of the bird seeks for and watches the equally cautious movements of the objects towards which it advances with all imaginable care. When at a proper distance, it darts forth its bill with astonishing celerity, to pierce and secure its prey. . . .

Audubon, *Birds of America*, 6:149

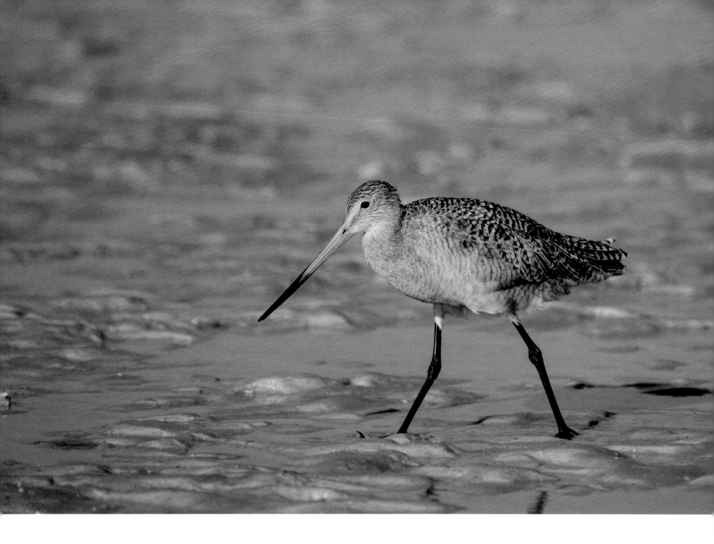

Marbled Godwit

Fort De Soto County Park, Tierra Verde, FL

But the instant the water began to recede they would right about face and trot back with it, splashing it up so that you could see it glisten. As they went their long bill in the low afternoon sun strikingly coral red except for the black tip were shoved ahead of them, feeding along through the wet sand, the light glinting from them; and if anything good was discovered deeper, the hunters would stop to probe, sometimes plunging the bill in up to the hilt, on rare occasions when the tidbit proved out of reach, actually crowding their heads down into the sand.

Bailey, "A Populous Shore," 101 (quoted in Bent, *Shore Birds*, 1:283)

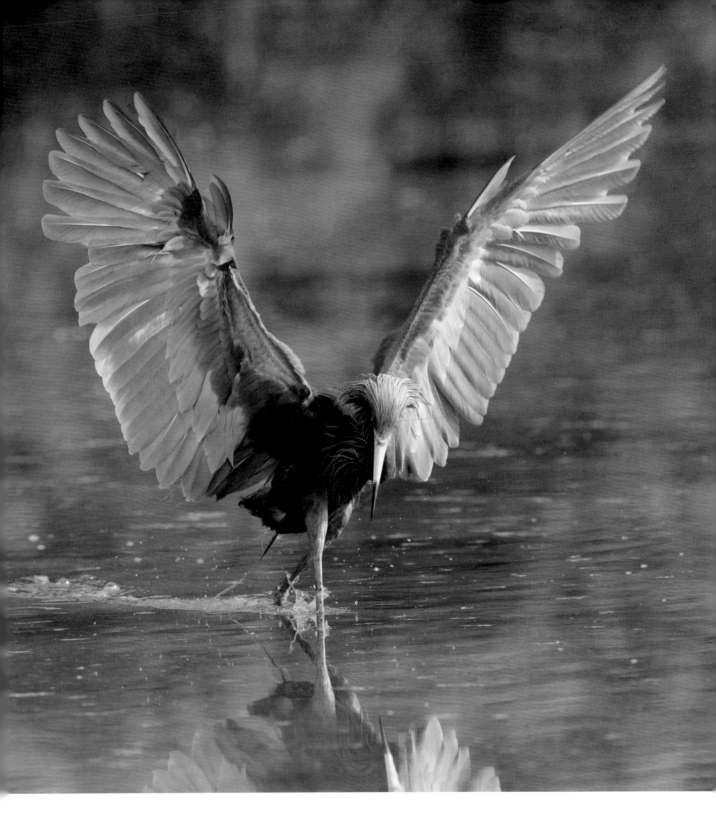

Reddish Egret

Tierra Verde, FL

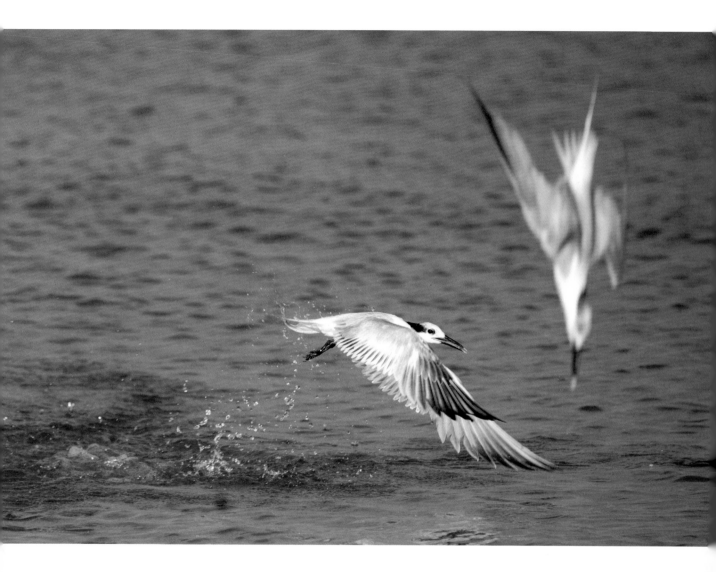

Sandwich Tern

Fort De Soto County Park, Tierra Verde, FL

In flight this is one of the swiftest and most skillful of the terns. Its long, slender, pointed form is highly specialized for speed and ease in cutting the air . . .

Bent, *Gulls*, 225–226

Sandwich Tern

Fort De Soto County Park, Tierra Verde, FL

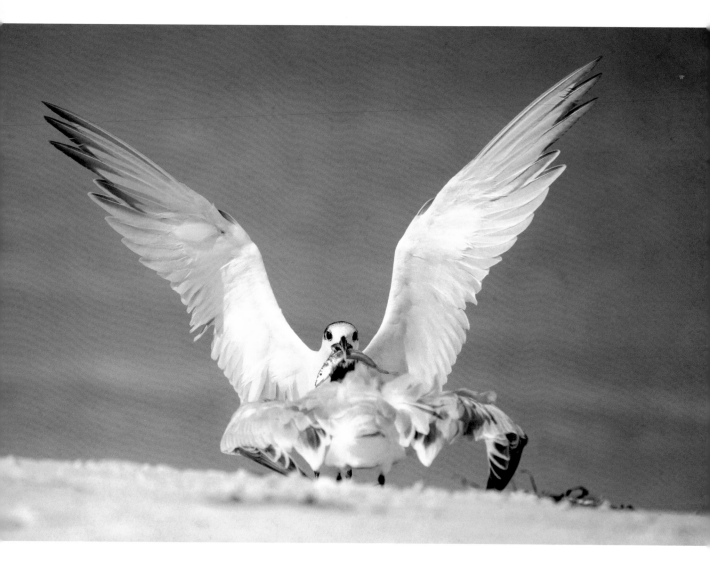

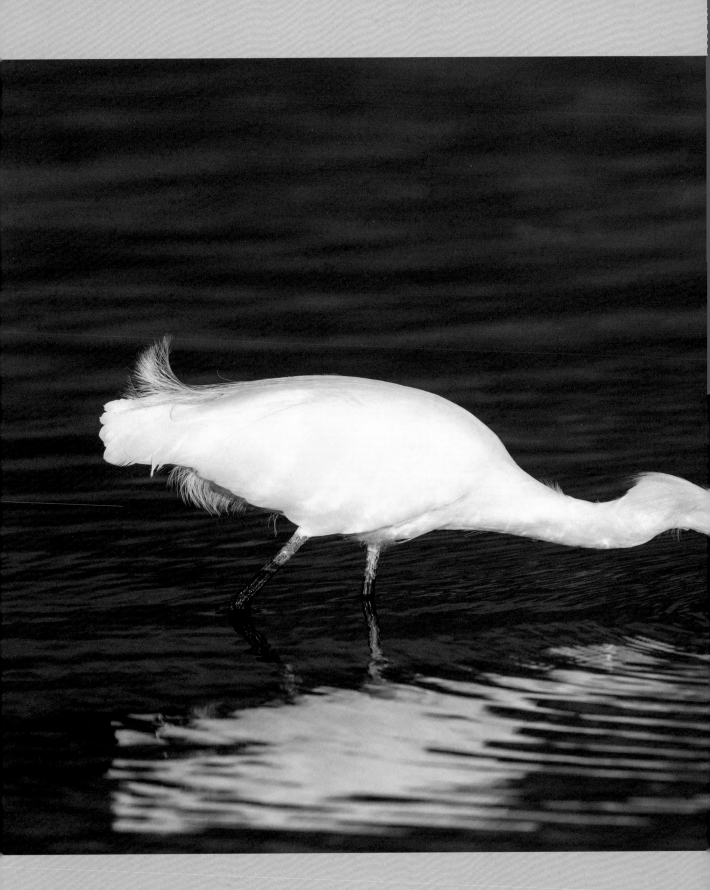

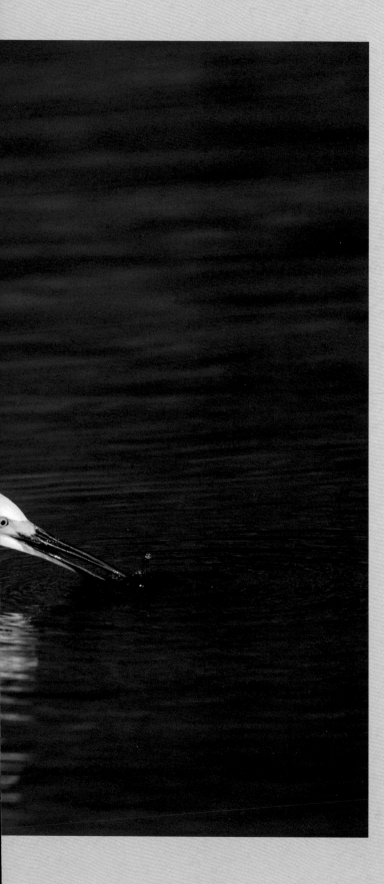

Snowy Egret

Fort De Soto County Park, Tierra Verde, FL

Blowing bubbles to attract prey

Tricolored Heron

Tierra Verde, FL

Stealing quietly along, with cautious and measured steps, its quick eye detects the presence of a school of minnows; then crouching low, with head drawn in, it takes a few rapid steps, its sharp beak darts swiftly outward and downward with unerring aim; sometimes it misses but often two or three of the small fry are caught before the school escapes. Its movements are so graceful, so swift and so accurate that it is a pleasure to watch them.

Bent, *Marsh Birds*, 174

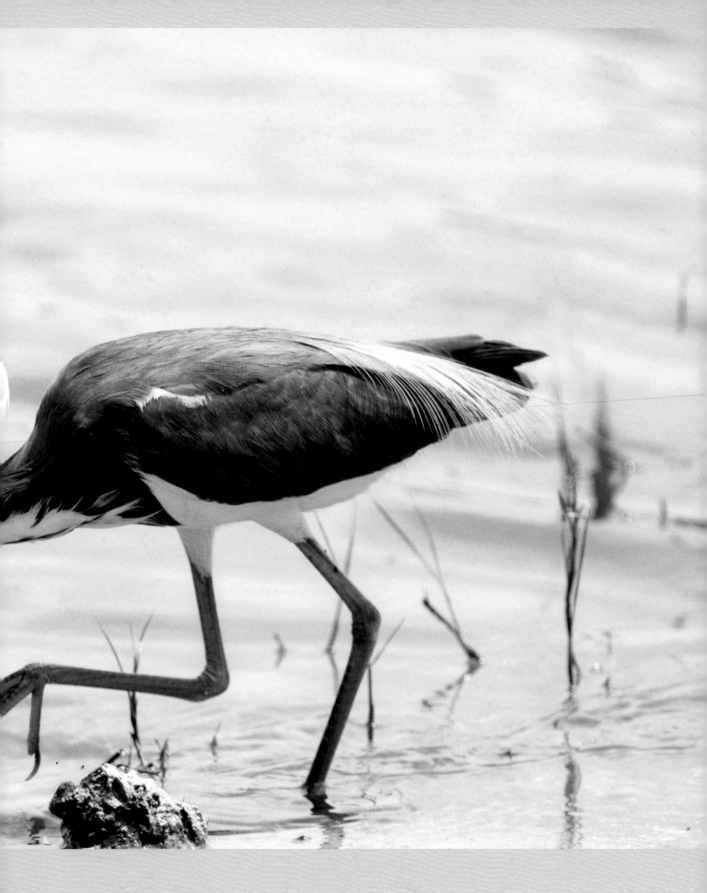

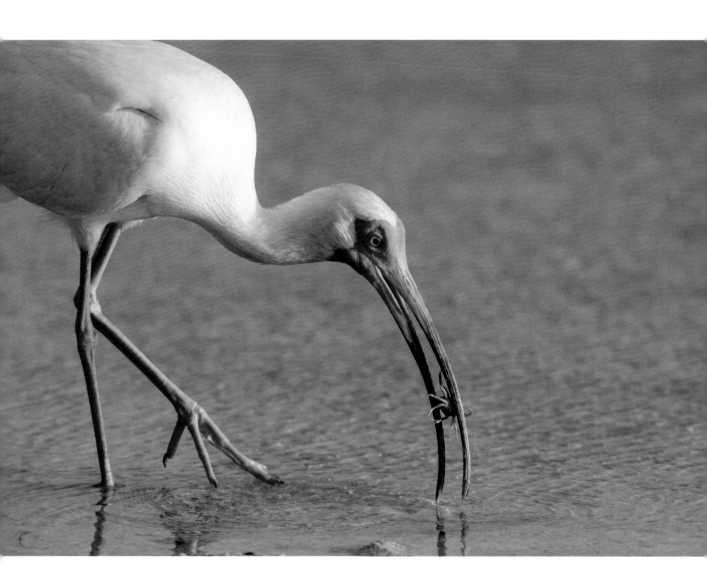

White Ibis

Fort De Soto County Park, Tierra Verde, FL

I have always found this species very shy and difficult to approach, especially when feeding, but when they have had their fill of crawfish and other small crustaceans, of which they are very fond, and are resting on the bushes, they may be approached quite closely by using caution.

Maynard, *Birds of Eastern North America*, 140

THE LOVE SEASON

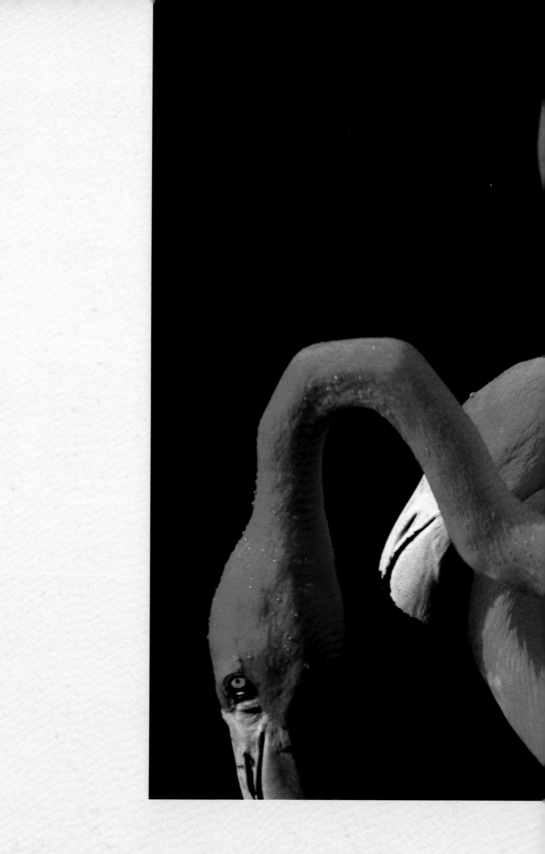

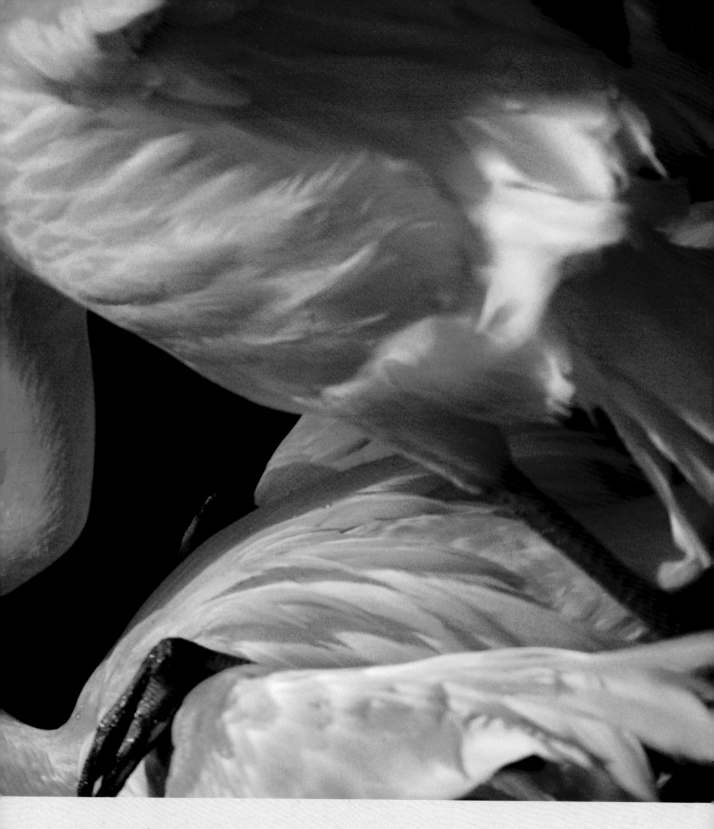

American Flamingo
Homosassa Springs Wildlife State Park, Homosassa Springs, FL

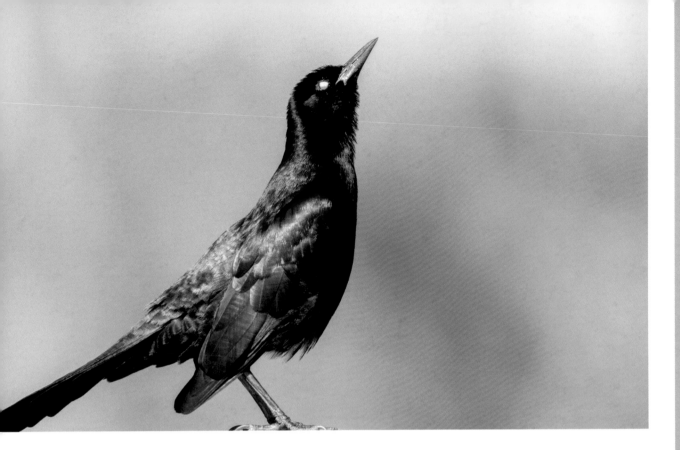

Boat-tailed Grackle

St. Marks National Wildlife Refuge, FL

[T]hey have a singular way of exhibiting their excitement, which I never observed in any other species, for they draw the nictitating membrane of the eye backwards and forwards very rapidly.

Maynard, *Birds of Eastern North America*, 450–451

Great Blue Heron (*opposite*)

Venice Rookery, Venice, FL

Occasionally we saw the ceremony of nest relief, a spectacular performance; with much loud croaking, to which his mate replies, the male alights in the top of the nest-tree or one near it; with much display of plumage, raised wings and elevated plumes, he walks along or down the branches to the nest, where he greets and caresses his mate; she responds by lifting her head and raising the plumes above her back; in graceful attitudes they admire each others charms, a beautiful picture of conjugal happiness and a great display of purest loveliness; after a few moments she departs and he assumes charge of the nest.

Bent, *Marsh Birds*, 135

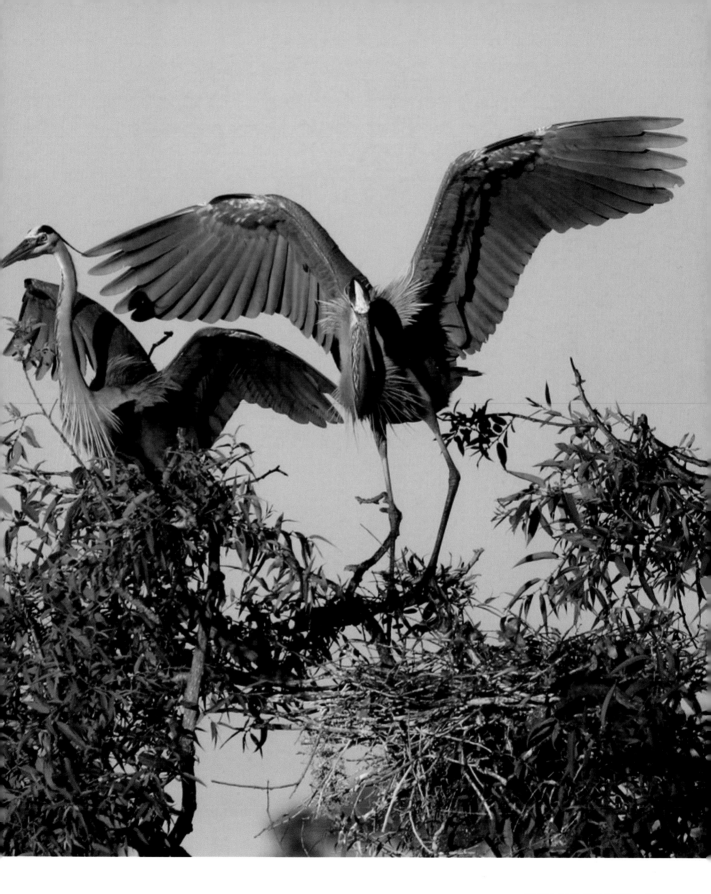

Great Blue Heron

Venice Rookery, Venice, FL

The male and the female sit alternately, receiving food from each other, their mutual affection being as great as it is towards their young...

Audubon, *Birds of America,* 6:133

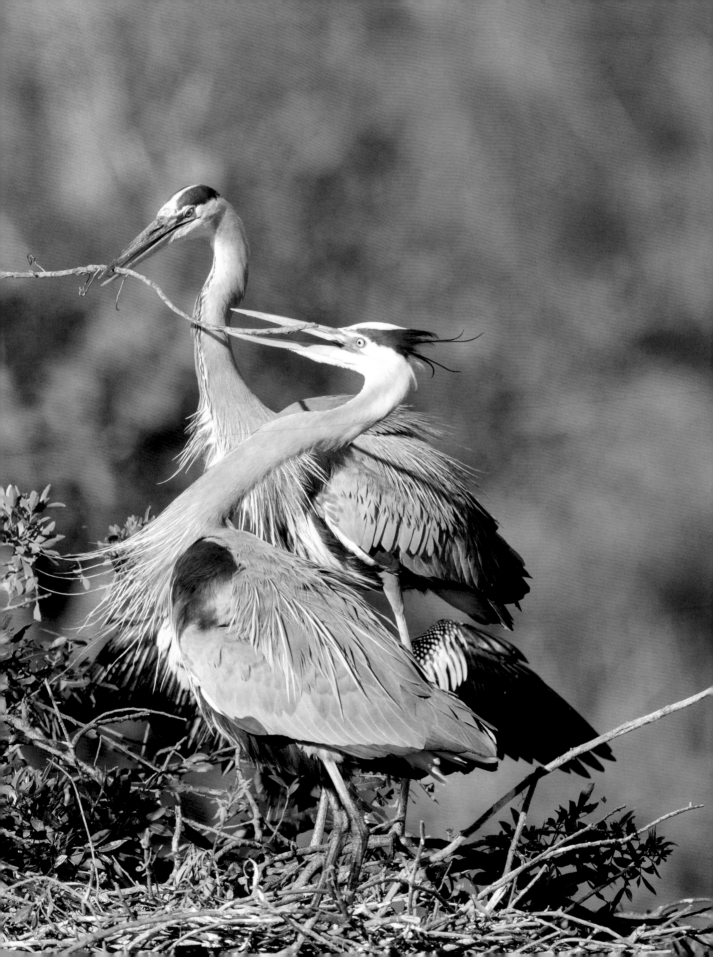

Great Egret

Homosassa Springs Wildlife State Park, Homosassa Springs, FL

 The train, which extends 7 or 8 inches beyond the tail, is composed of a great number of long, thick, tapering shafts, arising from the lower part of the shoulders, and thinlv furnished on each side with fine flowing, hair-like threads, several inches in length, covering the lower part of the back, and falling gracefully over the tail, which it entirely conceals. The whole plumage pure white, except the train, which is slightly tinged with yellow.

Nuttall, *Water Birds*, 48

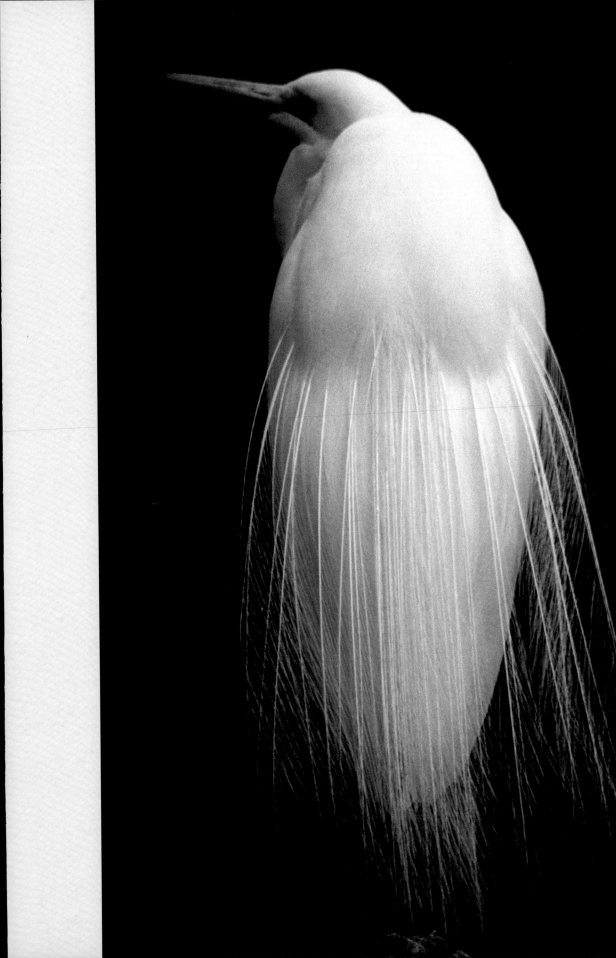

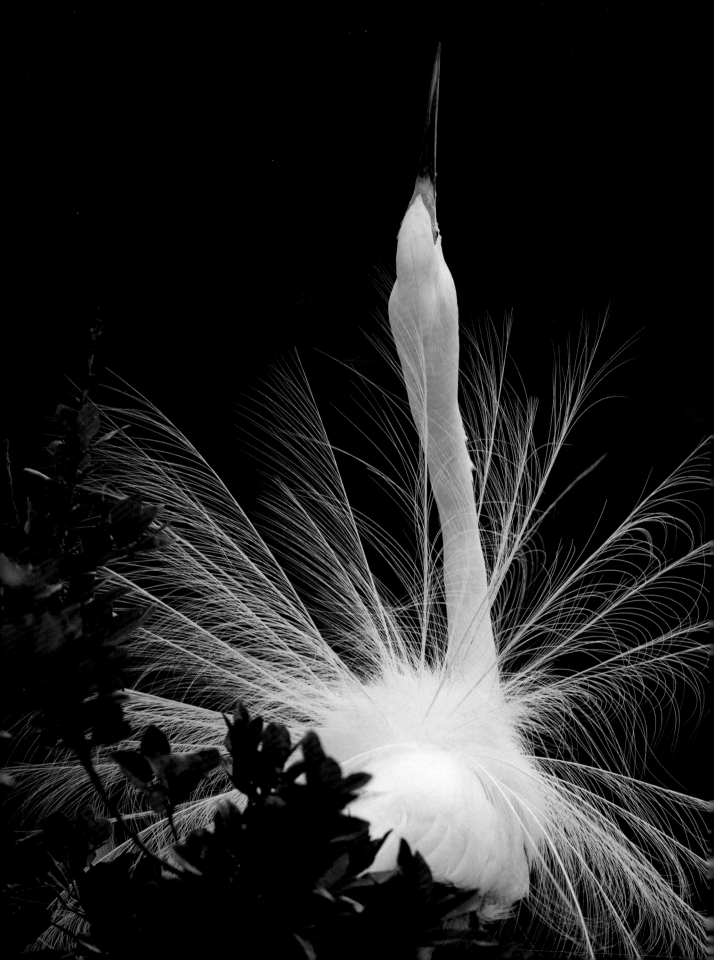

Great Egret

St. Augustine Alligator Farm, St. Augustine, FL

Near the plantation of John Bulow, Esq. in East Florida, I had the pleasure of witnessing this sort of tournament or dress-ball from a place of concealment not more than a hundred yards distant. The males, in strutting round the females, swelled their throats, as Cormorants do at times, emitted gurgling sounds, and raising their long plumes almost erect, paced majestically before the fair ones of their choice.

Audubon, *Birds of America,* 6:132

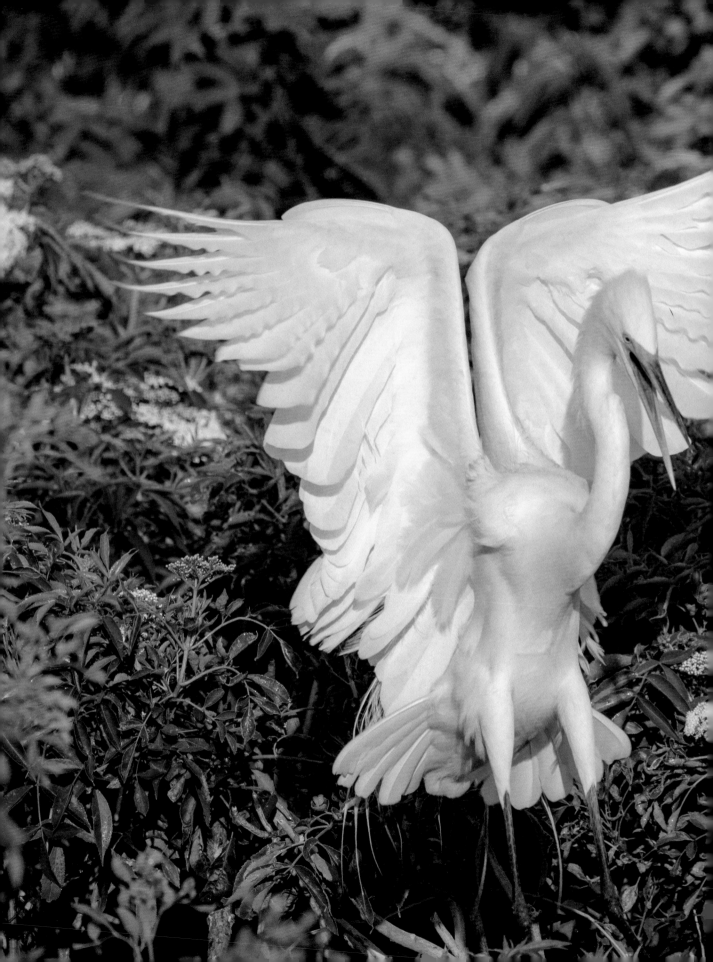

Great Egret

St. Augustine Alligator Farm, St. Augustine, FL

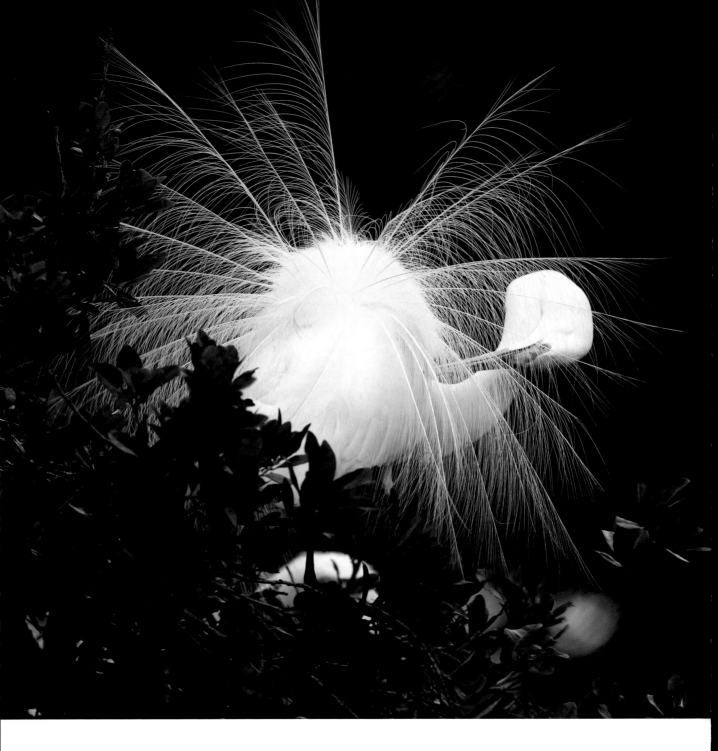

Great Egret

St. Augustine Alligator Farm, St. Augustine, FL

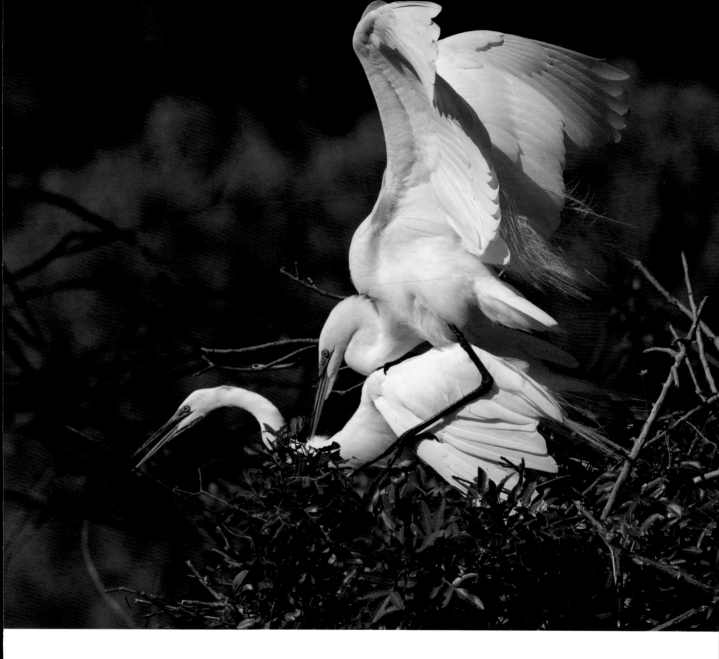

Great Egret

Gatorland, Orlando, FL

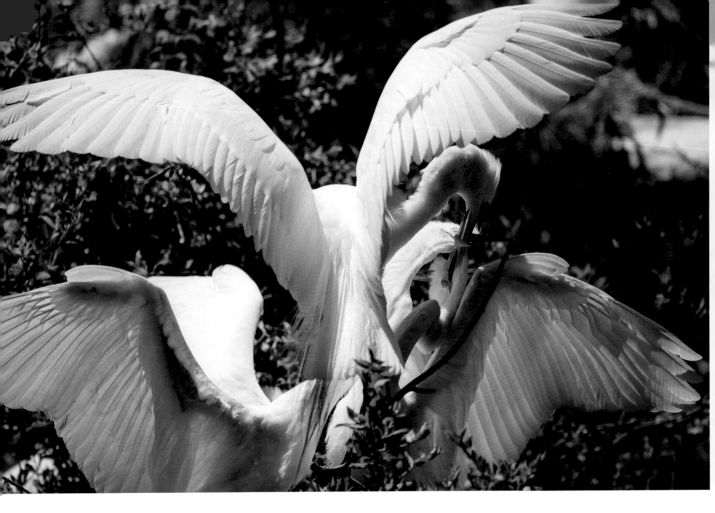

Great Egret

Gatorland, Orlando, FL

The old bird approaches with deliberate dignity and may stand on the nest for a few minutes with her head high in the air. Then with crest and plumes erected and with a pumping motion, she lowers her head and one of the youngsters grabs her bill in his, crosswise; the wrestling match then follows until the food passes into the young bird's mouth or onto the next. The young are usually fed in rotation, but often the most aggressive youngster gets more than his share.

Bent, *Marsh Birds*, 106, describing the similar habits of the Great Blue Heron

Little Blue Heron (*opposite*)

St. Augustine Alligator Farm, St. Augustine, FL

From the Breast hang long narrow Feathers, as there do likewise from the Hind-part of the Head; and likewise on the Back are such like Feathers, which are a Foot in Length, and extend four Inches below the Tail, which is a little shorter than the Wings.

Catesby, *Natural History*, 1:76

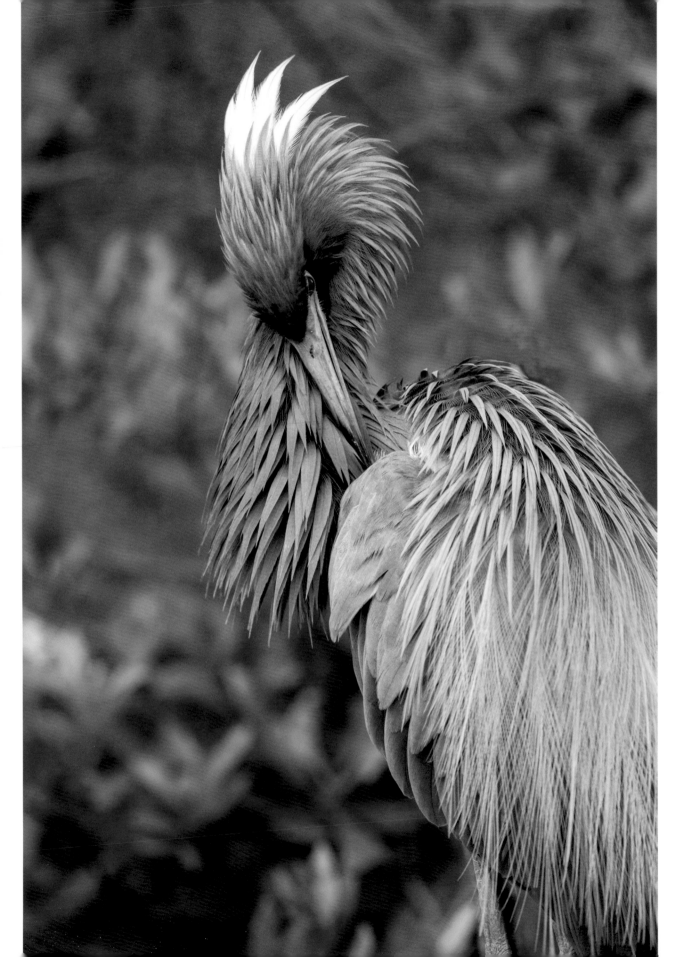

Osprey

Apalachicola, FL

Ospreys often build on telegraph or telephone poles, where the cross arms and wires give good support, much to the annoyance of the linemen who have to remove the nests.

Bent, *Birds of Prey*, 356

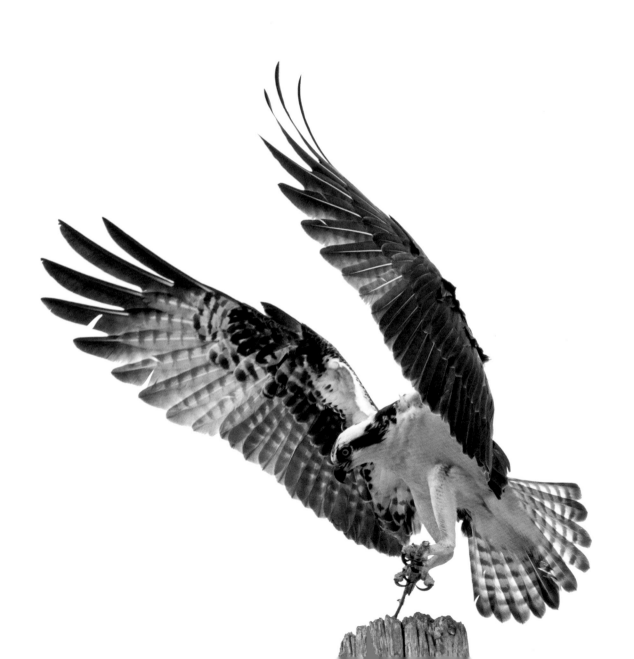

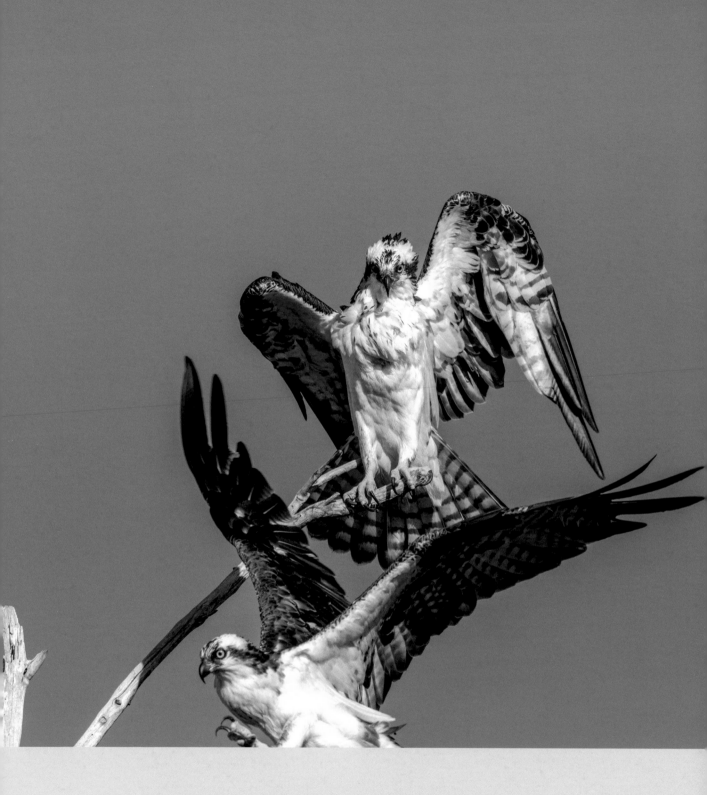

Osprey

St. Marks National Wildlife Refuge, FL

Sandhill Crane

East Lake Tohopekaliga, Kissimmee, FL

Both birds then joined in a series of loud rolling cries in quick succession. Suddenly the newcomer, which appeared to be a male, wheeled his back toward the female and made a low bow, his head nearly touching the ground, and ending by a quick leap into the air; another pirouette brings him facing his charmer, whom he greets with a still deeper bow, his wings meanwhile hanging loosely by his sides. She replies by an answering bow and hop, and then each tries to outdo the other in a series of spasmodic hops and starts, mixed with a set of comically grave and ceremonious bows.

Nelson, *Natural History Collections*, 95 (quoted in Bent, *Marsh Birds*, 232)

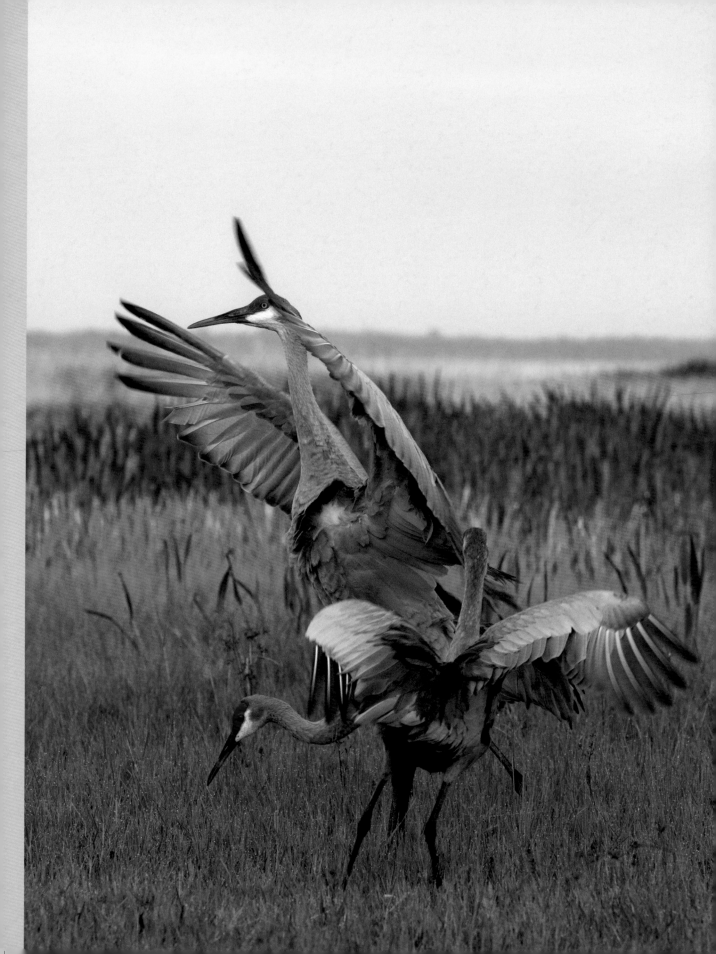

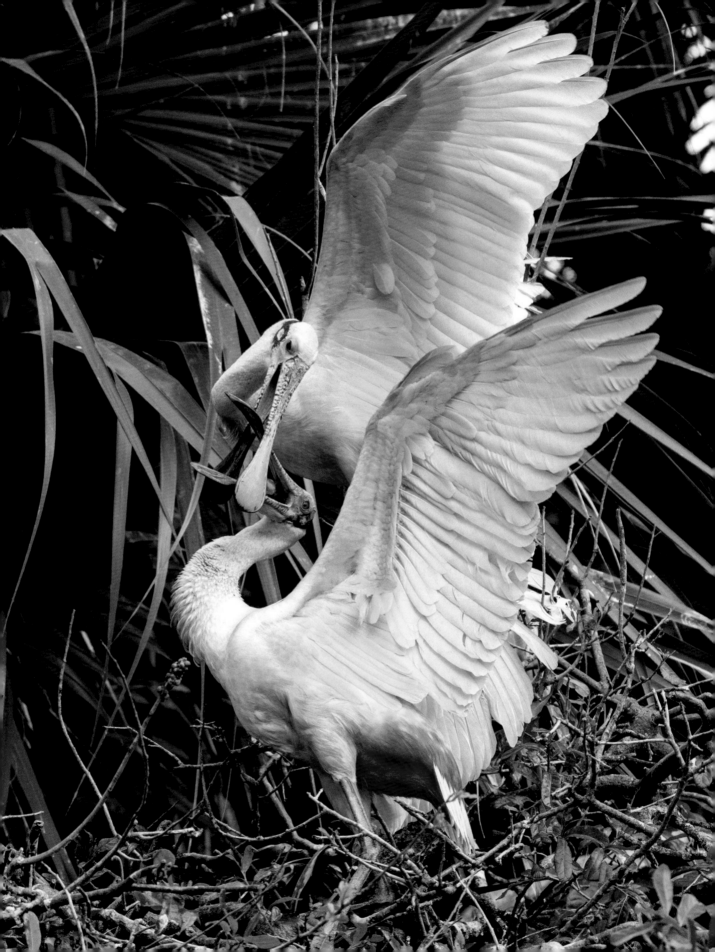

Roseate Spoonbill

St. Augustine Alligator Farm, St. Augustine, FL

"Billing" skirmish, during nesting season

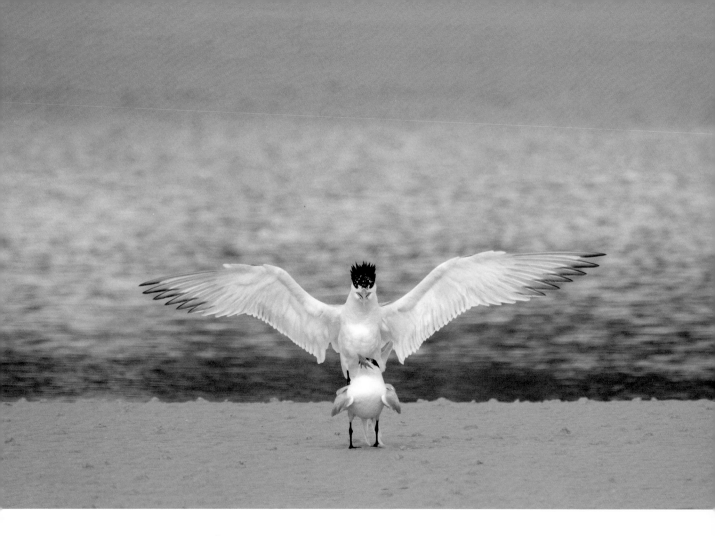

Royal Tern

Fort De Soto County Park, Tierra Verde, FL

Snowy Egret (*opposite*)

St. Augustine Alligator Farm, St. Augustine, FL

. . . the head is largely crested with loose unwebbed feathers, nearly four inches in length; another tuft of the same covers the breast; but the most distinguished ornament of this bird is a bunch of long silky plumes, proceeding from the shoulders, covering the whole back, and extending beyond the tail: the shafts of these are six or seven inches long, extremely elastic, tapering to the extremities, and thinly set with long slender bending threads or fibres, easily agitated by the slightest motion of the air—these shafts curl upwards at the ends. When the bird is irritated, and erects those airy plumes, they have a very elegant appearance . . .

Wilson, *American Ornithology*, 3:81–82

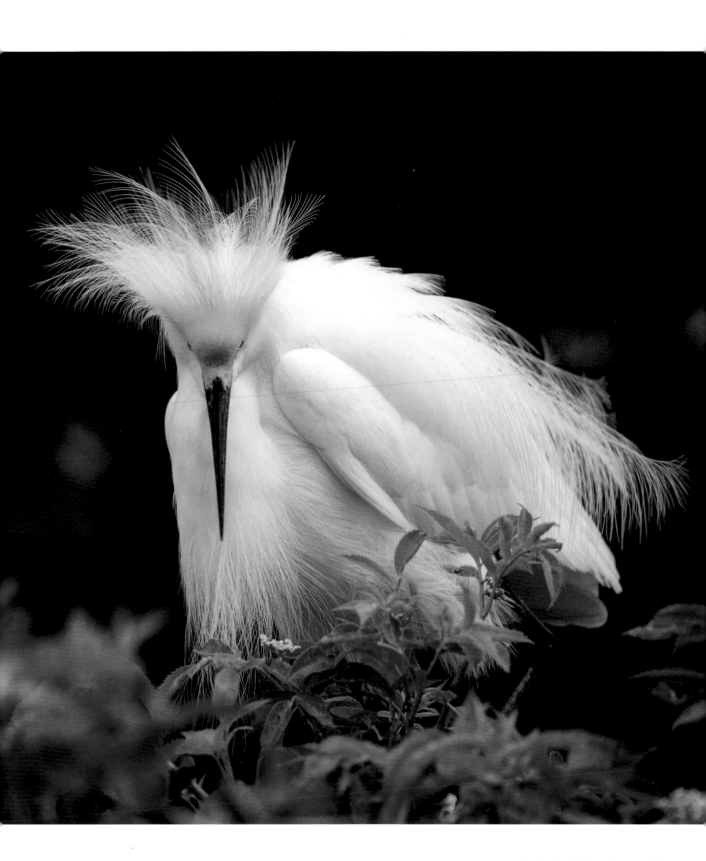

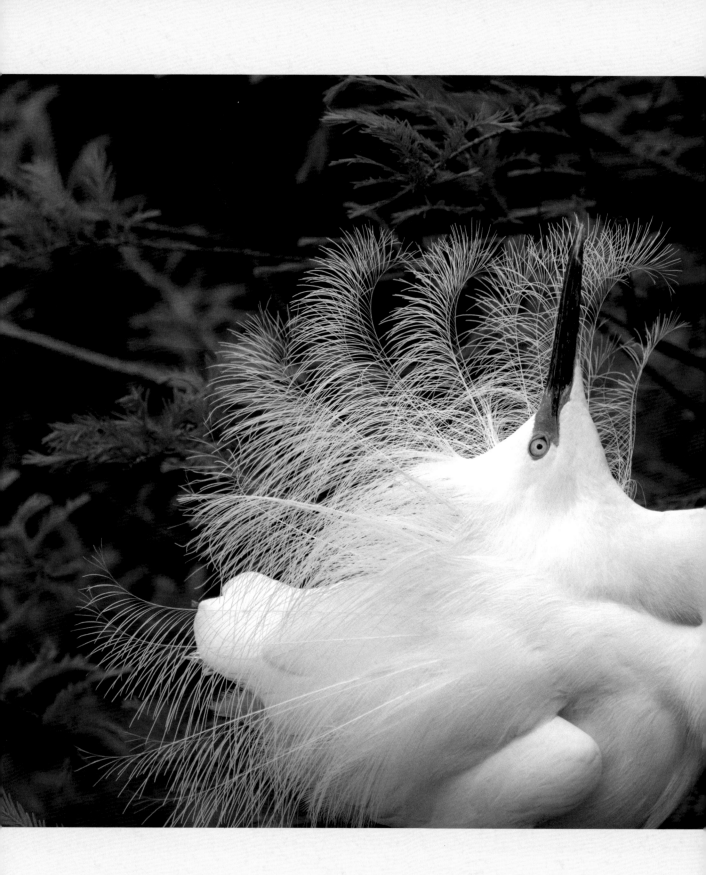

Snowy Egret

St. Augustine Alligator Farm, St. Augustine, FL

In the full display, the body is bent forward and downward, the neck is held in a graceful curve, the feathers of the head are raised in a vertical crest, the breast plumes are spread forward downward, the wings are partially open and raised, and the plumes of the back are elevated and spread, with their curving tips waving in the air. Such a picture must be seen to be appreciated; no written words or printed photograph can do it justice.

Bent, *Marsh Birds*, 146–147

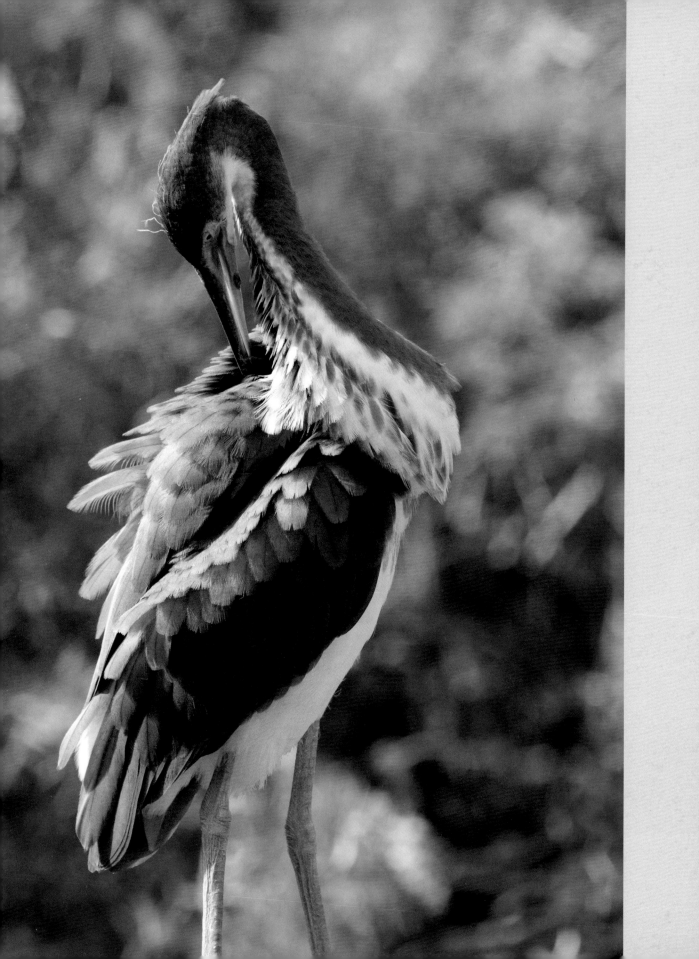

Tricolored Heron

St. Augustine Alligator Farm, St. Augustine, FL

Watch its motions, as it leisurely walks over the pure sand beaches of the coast of Florida, arrayed in the full beauty of its spring plumage. Its pendent crest exhibits its glossy tints, its train falls gracefully over a well defined tail, and the tempered hues of its back and wings contrast with those of its lower parts.

Audubon, *Birds of America*, 7:156

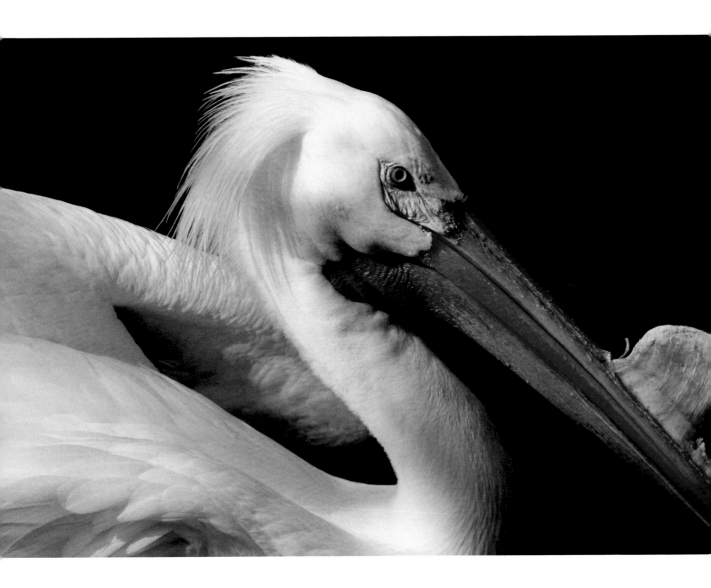

White Pelican

Homosassa Springs Wildlife State Park, Homosassa Springs, FL

The crest-like excrescence on the ridge of the upper mandible is not formed of bone, nor otherwise connected with the osseous surface, which is smooth and continuous beneath it, than by being placed upon it, like any other part of the skin. . . . It is composed internally of erect slender plates of a fibrous texture, externally of horny fibres, which are erect on the sides, and longitudinal on the broadened ridge. . . .

Audubon, *Birds of America*, 7:28

ELEGANT FORM & SPLENDID PLUMAGE

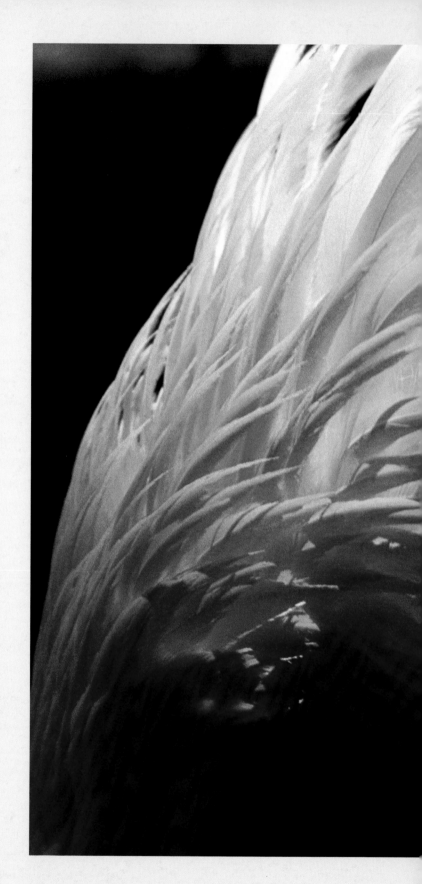

American Flamingo
Homosassa Springs Wildlife State Park,
Homosassa Springs, FL

There are larger birds than the Flamingo,
and birds with more brilliant plumage,
but no other large bird is so brightly
colored and no other brightly colored
bird is so large. In brief, size and beauty
of plume united, reach their maximum
of development in this remarkable bird,
while the open nature of its haunts and its
gregariousness seem specially designed to
display its marked characteristics of form
and color to the most striking advantage.

Chapman, *Camps and Cruises*, 155

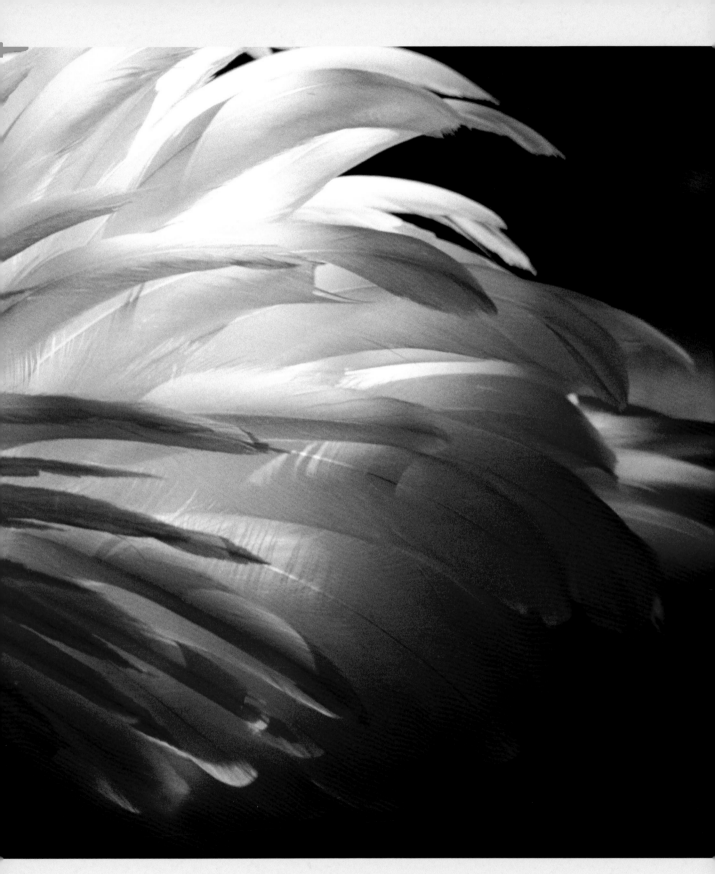

Brown Pelican

Apalachicola, FL

Now they droop their wings for awhile, or stretch them alternately to their full extent; some slowly lie down on the sand, others remain standing, quietly draw their head over their broad shoulders, raise one of their feet, and placing their bill on their back, compose themselves to rest. There let them repose in peace.

Audubon, *Birds of America*, 7:34

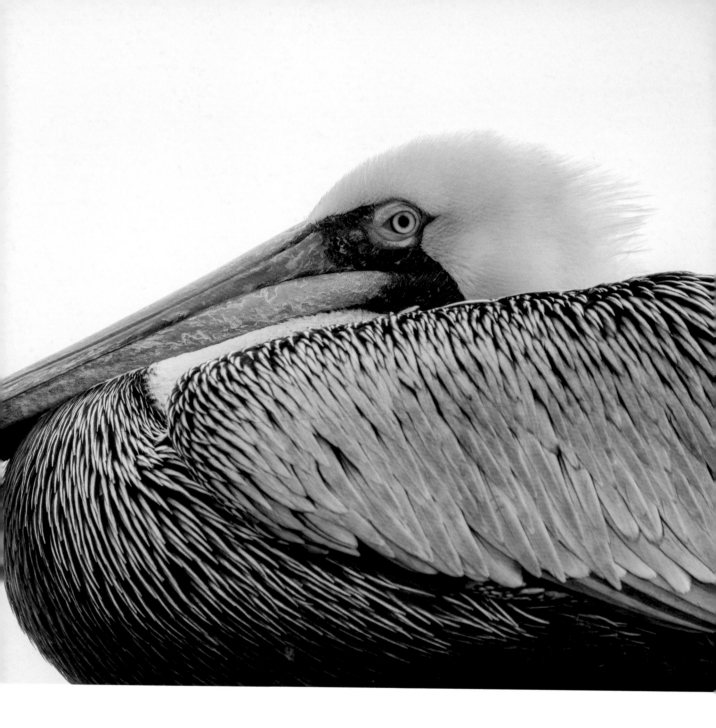

Common Grackle

St. Augustine Pier, St. Augustine, FL

The genial rays of the sun shine on their silky plumage, and offer to the ploughman's eye such rich and varying tints, that no painter, however gifted, could ever imitate them. The coppery bronze, which in one light shews its rich gloss, is, by the least motion of the bird, changed in a moment to brilliant and deep azure, and again, in the next light, becomes refulgent sapphire or emerald-green.

<div align="right">

Audubon, *Birds of America*, 4:58

</div>

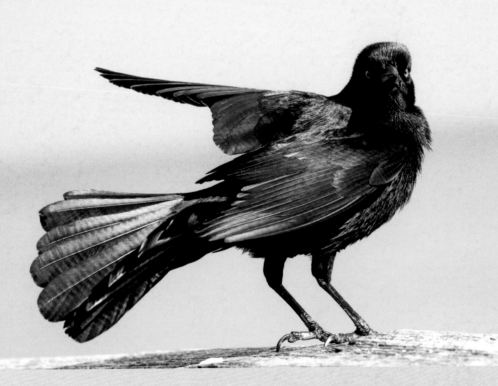

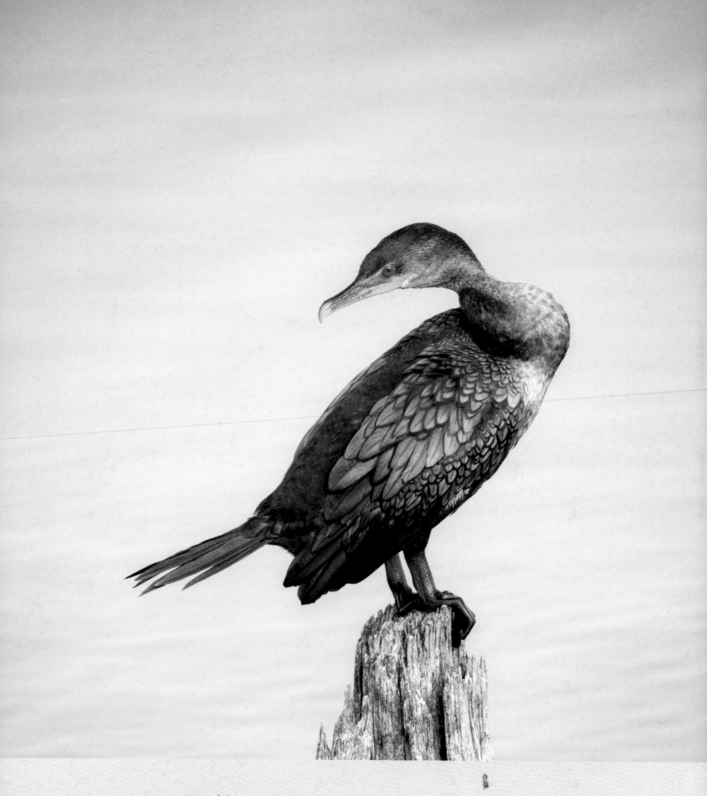

Double-crested Cormorant

St. Marks National Wildlife Refuge, FL

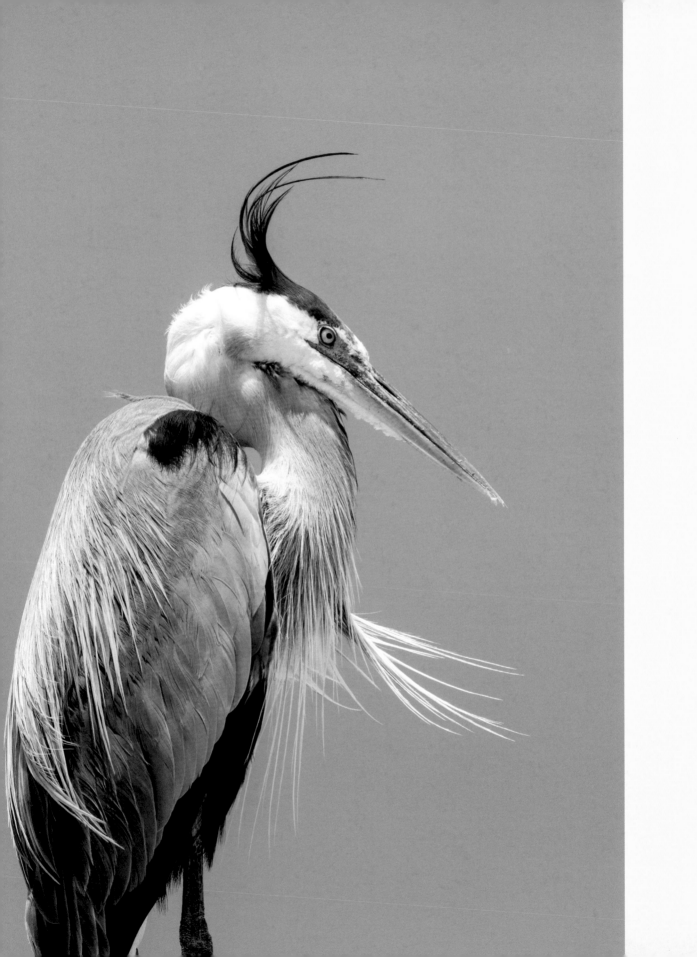

Great Blue Heron

Fort De Soto County Park, Tierra Verde, FL

I discovered the splendid creature perched on the higher growth to the left, clean-cut and statuesque against the sky. She stood there calmly, showing no trace of the intense excitement which now possessed her offspring; and quietly surveyed her surroundings. Assured that all was well, with erect plumes and partly expanded wings, she slowly walked downward toward the nest, with a dignity of motion and majesty of pose I have never seen excelled by any other bird.

Chapman, *Camps and Cruises*, 119

Great Blue Heron

Fort De Soto County Park, Tierra Verde, FL

 The principal food of the Great Heron is fish, for which he watches with the most unwearied patience, and seizes them with surprising dexterity. At the edge of the river, pond or seashore he stands fixed and motionless, sometimes for hours together. But his stroke is quick as thought, and sure as fate to the first luckless fish that approaches within his reach; these he sometimes beats to death, and always swallows head foremost, such being their uniform position in the stomach.

<div align="right">

Wilson, *American Ornithology*, 3:59

</div>

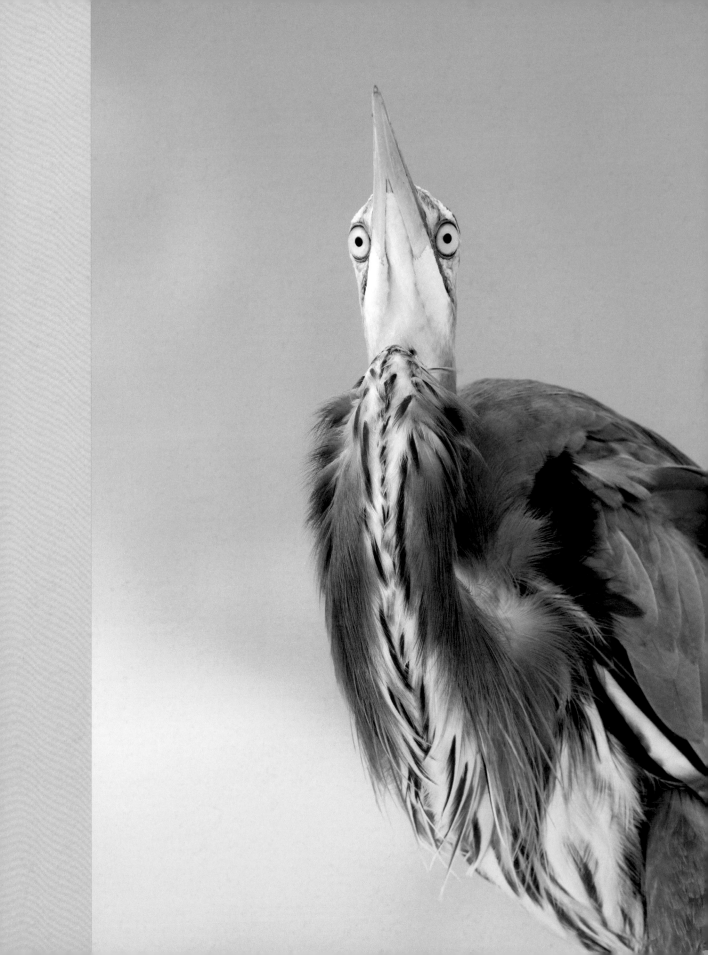

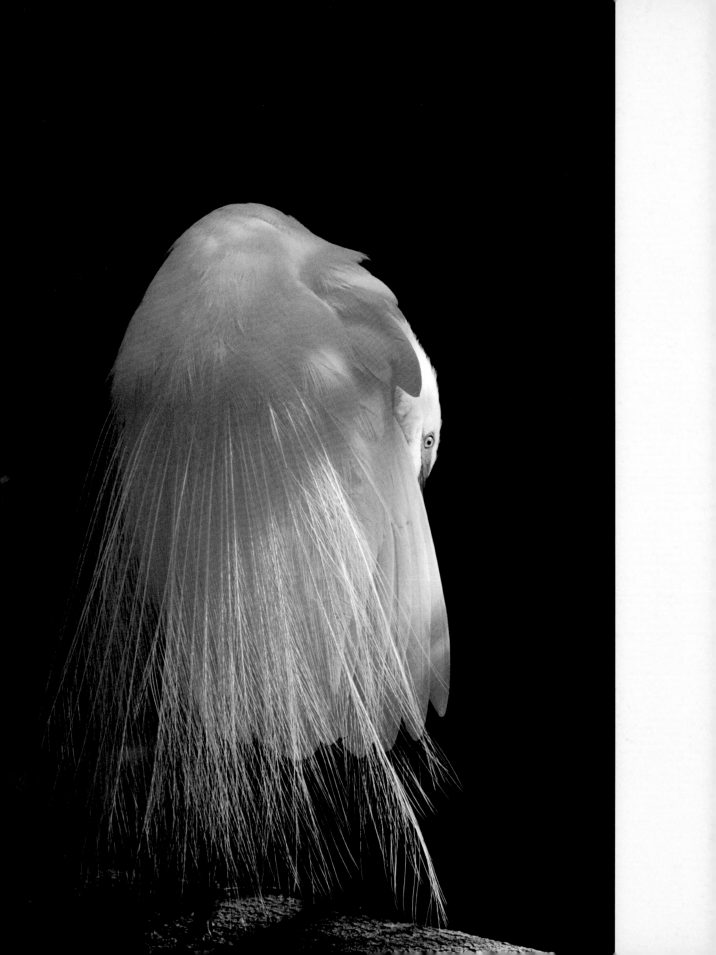

Great Egret

Homosassa Springs Wildlife State Park, Homosassa Springs, FL

[I]ts silky train reminded one of the flowing robes of the noble ladies of Europe. The train of this Egret, like that of other species, makes its appearance a few weeks previous to the love season, [and] continues to grow and increase in beauty, until incubation has commenced . . .

Audubon, *Birds of America*, 6:133

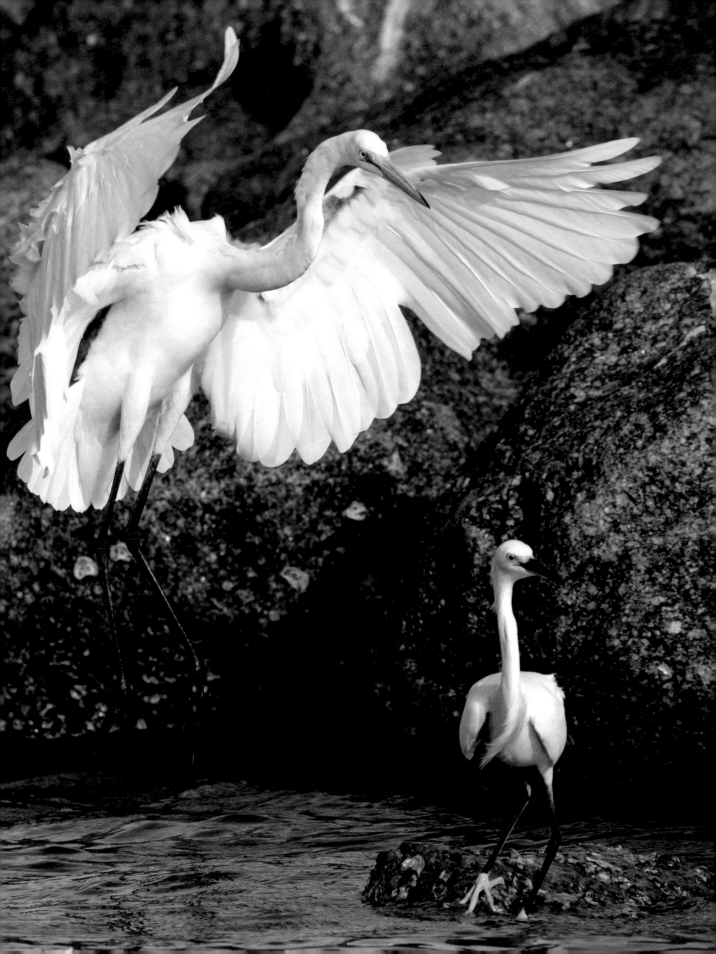

Great Egret and Snowy Egret

Fort De Soto County Park, Tierra Verde, FL

Great Egret

Lake Ella, Tallahassee, FL

Its long, smooth, slender neck, so expressive in its varied poses, its long, graceful, flowering plumes, reaching far beyond its tail like a bridal train, and the exquisite purity of its snowy-white plumage make a picture of striking beauty when sharply outlined against a background of dark green foliage or when clearly mirrored on the surface of a quiet pool.

Bent, *Marsh Birds*, 133–134

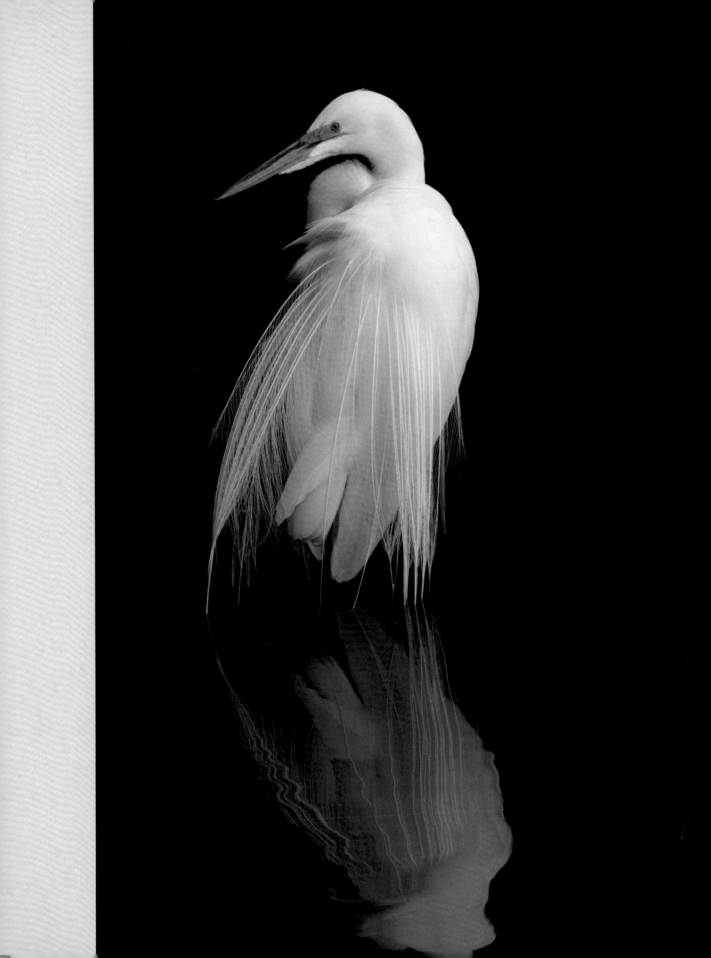

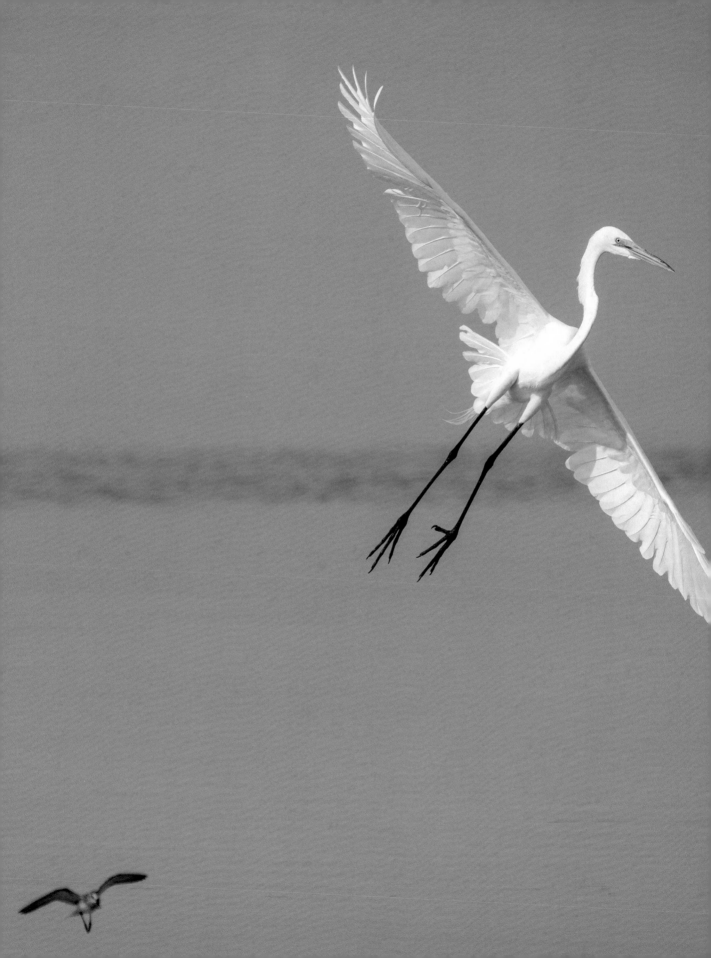

Great Egret

Fort De Soto County Park, Tierra Verde, FL

[A]s it springs into flight with neck and legs extended, and as it flaps majestically away on its broad white wings, it seems to be the longest, the slenderest, and the most ethereal of the herons.

Bent, *Marsh Birds*, 134

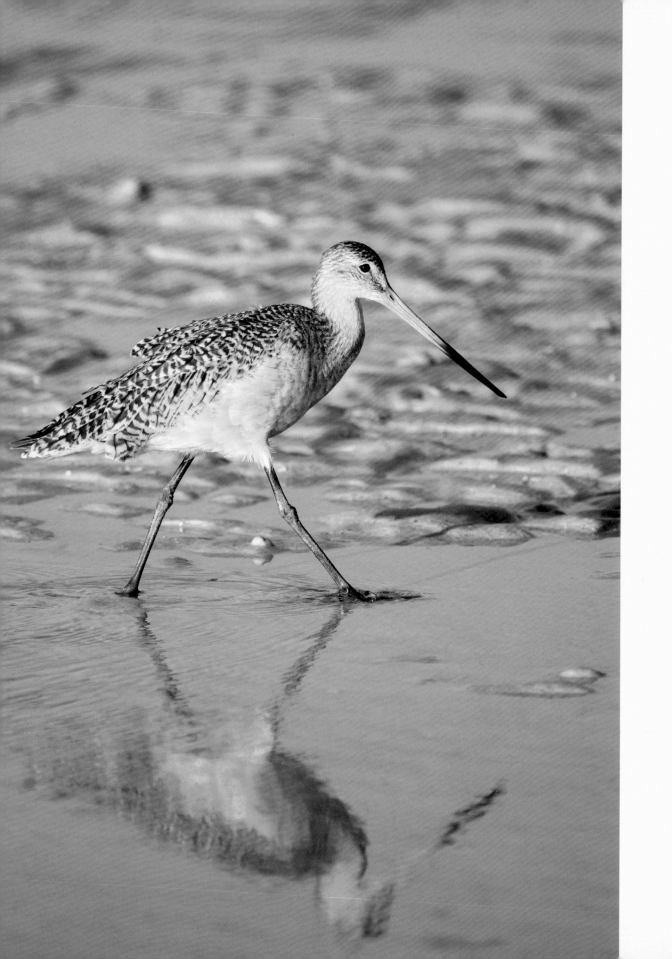

Marbled Godwit

Fort De Soto County Park, Tierra Verde, FL

While feeding, it probes the mud and wet sand, often plunging its bill to its whole length, in the manner of the Common Snipe and the Woodcock. It is fond of the small crabs called fiddlers, many of which it obtains both by probing their burrows, and running after them along the edges of the salt meadows and marshes.

Audubon, *Birds of America*, 5:331

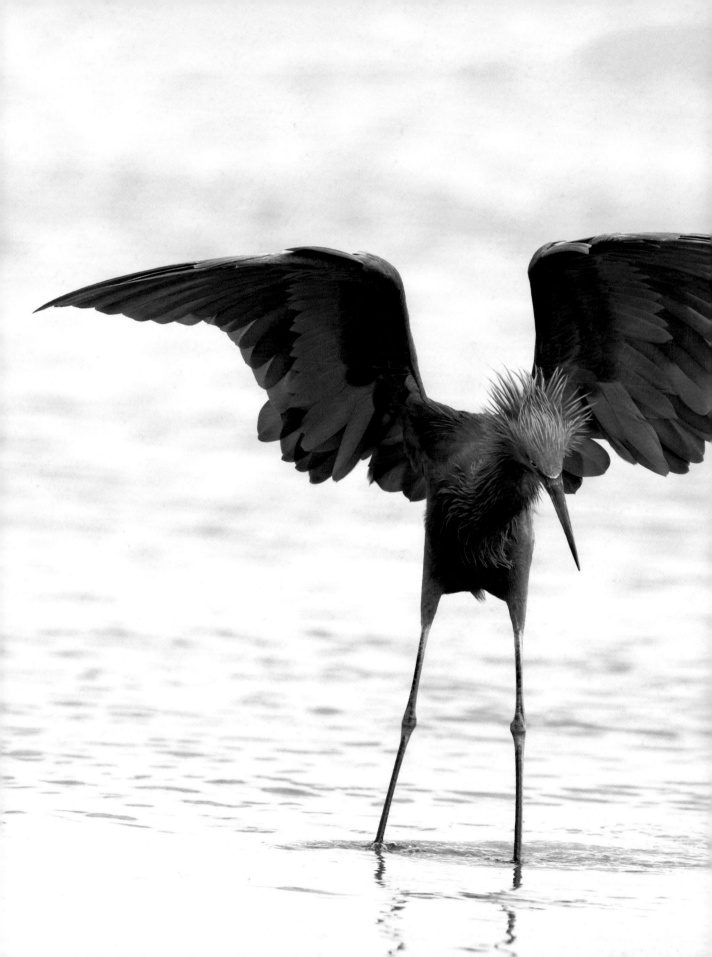

Reddish Egret

Fort De Soto County Park, Tierra Verde, FL

Red-breasted Merganser

Fort De Soto County Park, Tierra Verde, FL

As a diver the bird is truly an expert, and it disappears under water with wings close to its sides, making use of its powerful feet alone except on rare occasions when its wings are also brought into play. At times it leaps clear of the surface, describes a graceful arc and enters the water like a curved arrow, while at other times it disappears with scarcely a sign of effort.

Bent, *Wild Fowl*, 1:19

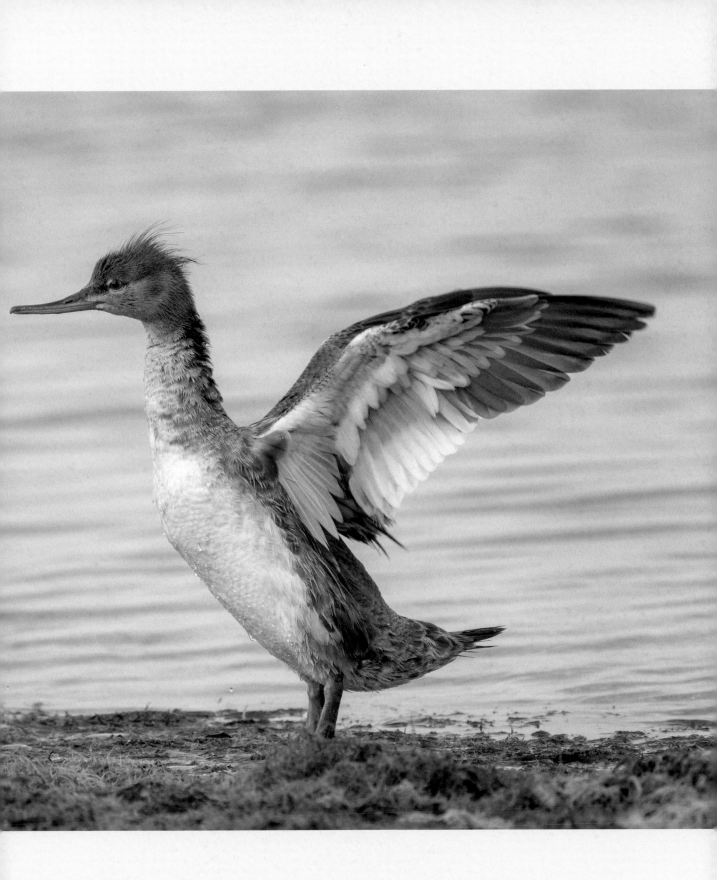

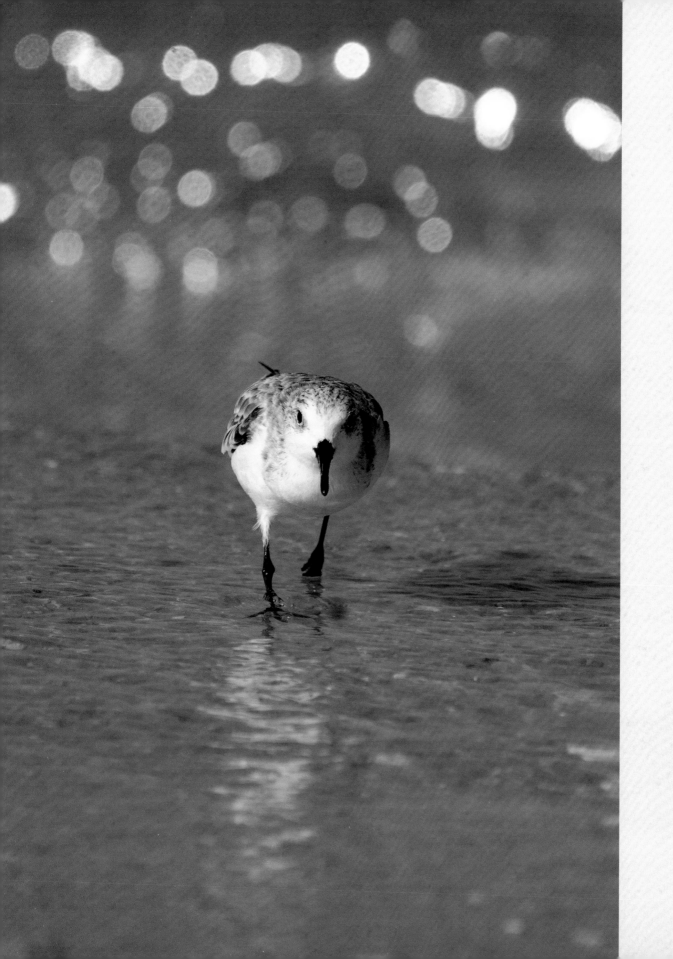

Red Knot

Fort De Soto County Park, Tierra Verde, FL

When not harassed they are by no means shy, allowing of a pretty near approach, while busily and sedately employed in gleaning their food along the strand, chiefly at the recess of the tide; where, in friendly company with the small Peep and other kindred species, the busy flocks are seen gleaning up the rejectamenta of the ocean, or quickly and intently probing the moist sand for worms and minute shell-fish, running nimbly before the invading surge, and profiting by what it leaves behind.

Nuttall, *Water Birds*, 127

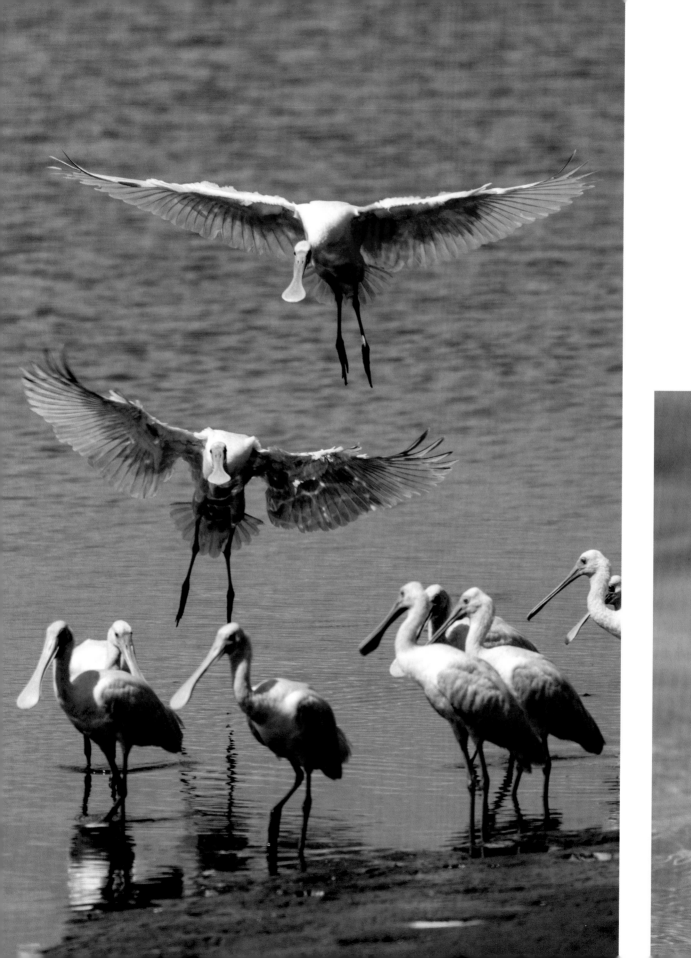

Roseate Spoonbill *(opposite)*

St. Marks National Wildlife Refuge, Panacea, FL

 Again, they all stalk about with graceful steps along the margin of the muddy pool, or wade in the shallows in search of food. After awhile they rise simultaneously on wing, and gradually ascend in a spiral manner to a great height, where you see them crossing each other in a thousand ways, like so many Vultures or Ibises. At length, tired of this pastime, or perhaps urged by hunger, they return to their feeding grounds in a zigzag course, and plunge through the air, as if displaying their powers of flight before you.

<div align="right">Audubon, Birds of America, 6:73</div>

Short-billed Dowitcher

Fort De Soto County Park, Tierra Verde, FL

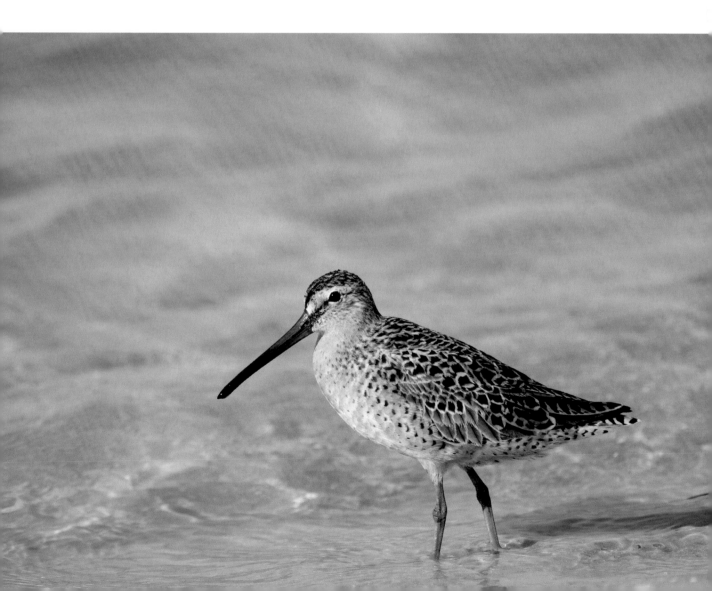

Snowy Egret

Lake Ella, Tallahassee, FL

The young acquire the full beauty of their plumage in the course of the first spring, when they can no longer be distinguished from the old birds. The legs and feet are at first of a darkish olive, as is the bill, except at the base, where it is lighter, and inclining to yellow. At the approach of autumn, the crest assumes a form, and the feathers of the lower parts of the neck in front become considerably lengthened, the feet acquire a yellow tint, and the legs are marked with black on a yellowish ground . . .

Audubon, *Birds of America*, 6:165

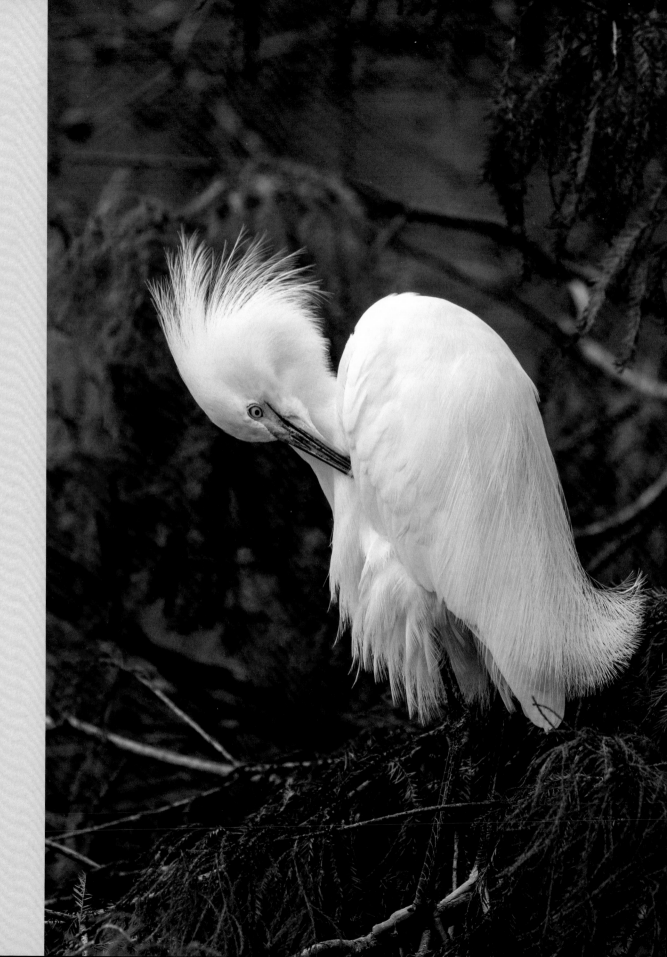

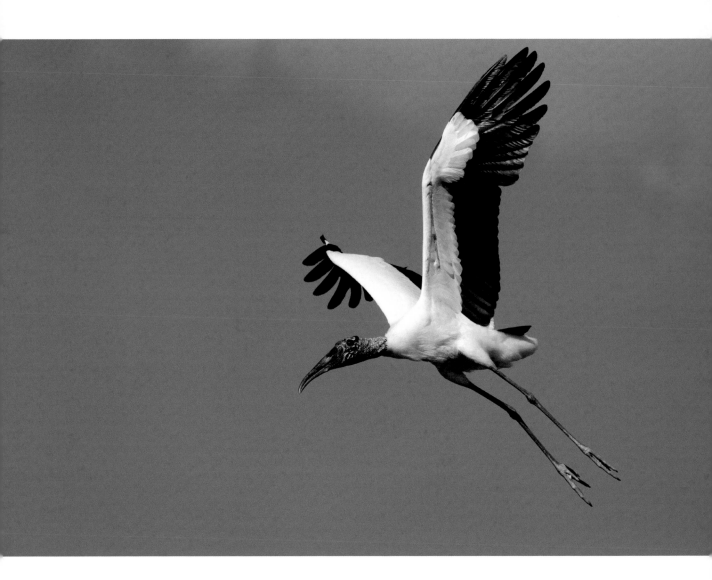

Wood Stork

St. Augustine Alligator Farm, St. Augustine, FL

In the rookery they frequently saw the birds flying overhead with long twigs or small branches, with leaves still on them, or with long streamers of moss for nest linings.

Bent, *Marsh Birds*, 59

IN THE SITUATION & CLIMATE IT INHABITS

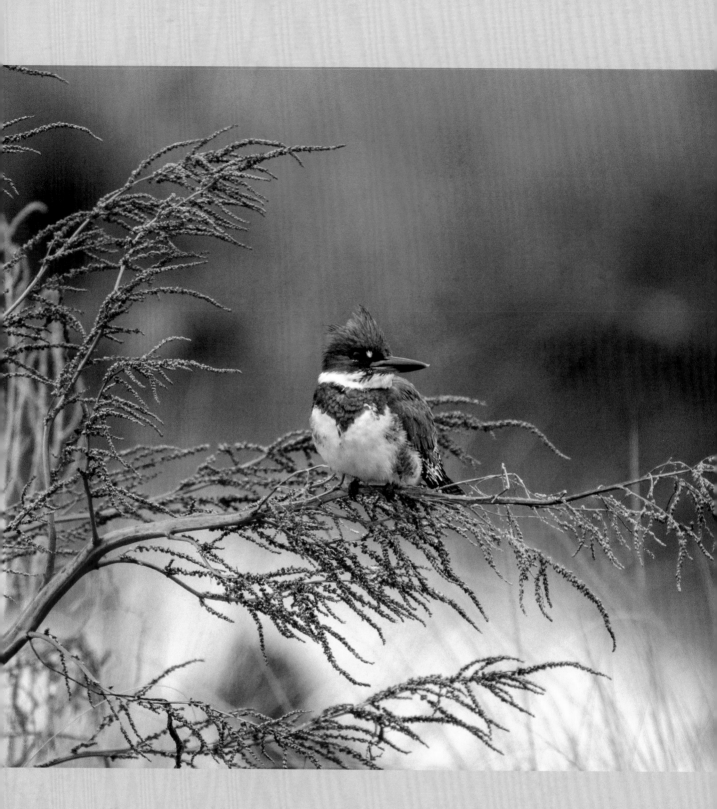

Belted Kingfisher

St. Marks National Wildlife Refuge, FL

Being essentially a fish-eating bird, its haunts are naturally near large or small bodies of water. It is common on the seacoast and estuaries, where it may be seen perched on some stake or pier, watching for its prey; or along the shore of a lake or pond, its favorite outlook may be the branch of a tree overhanging the water; I believe that it prefers to perch on a dead or leafless branch, where its view is unobstructed.

Bent, *Cuckoos*, 111

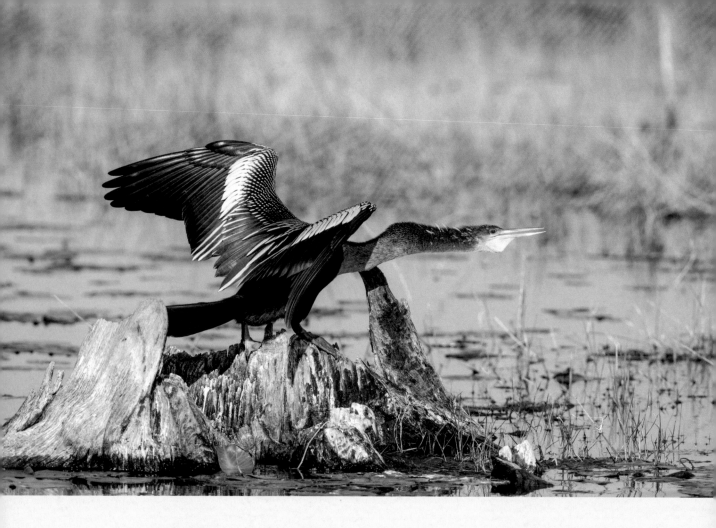

Anhinga
St. Marks National Wildlife Refuge, FL

. . . remarkable in form and manners, the Anhingas, or "Grecian Ladies," stand erect, with their wings and tail fully or partially spread out in the sunshine, whilst their long slender necks and heads are thrown as it were in every direction by the most curious and sudden jerks and bendings. Their bills are open, and you see that the intense heat of the atmosphere induces them to suffer their gular pouch to hang loosely.

<div align="right">Audubon, Birds of America, 6:446</div>

Anhinga (*opposite*)
St. Marks National Wildlife Refuge, FL

The Snake Birds, Anhingas, or Water Turkeys, as they are termed in various localities, are among the most singular and interesting birds found in Florida, for they possess habits which characterize several species, besides many which are peculiar to themselves. They perch on trees like Cormorants but spread their wings in the sun when sitting . . .

<div align="right">Maynard, Birds of Eastern North America, 58</div>

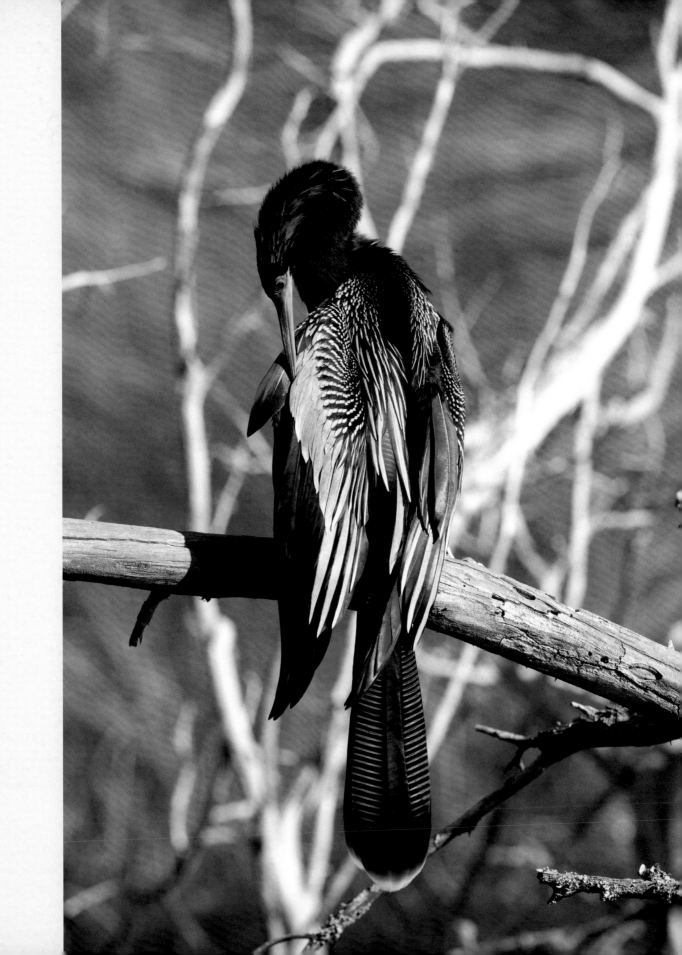

American Oystercatcher

Fort De Soto County Park, Tierra Verde, FL

The usual impression that one gets of this large and showy wader is a fleeting glimpse of a big, black and white bird disappearing in the distance over the hot, shimmering sands of our southern beaches. It is one of the shyest and wildest of our shore birds, ever on the alert to escape from danger. . . .

Bent, *Shore Birds*, 2:309

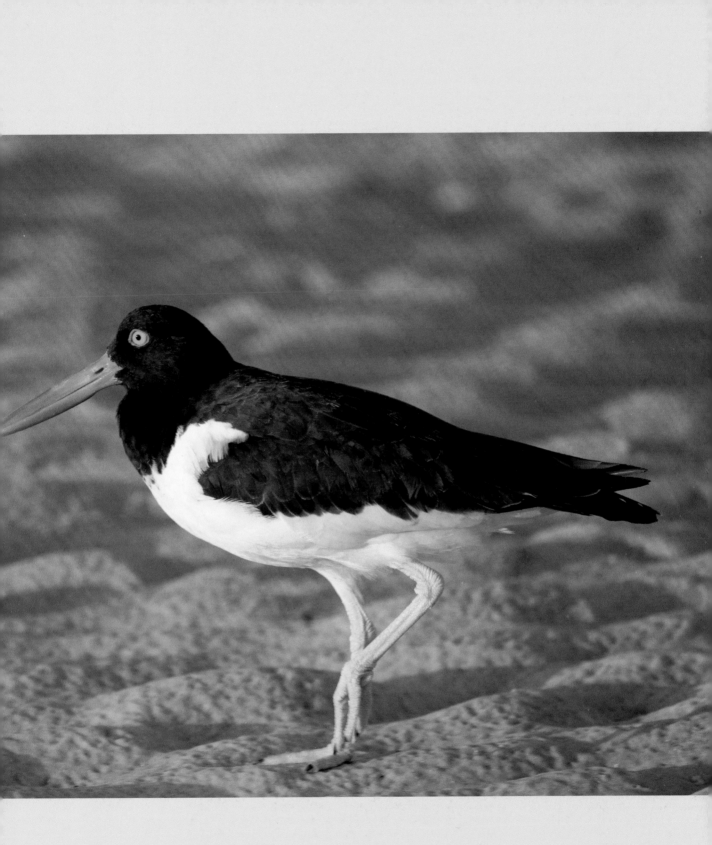

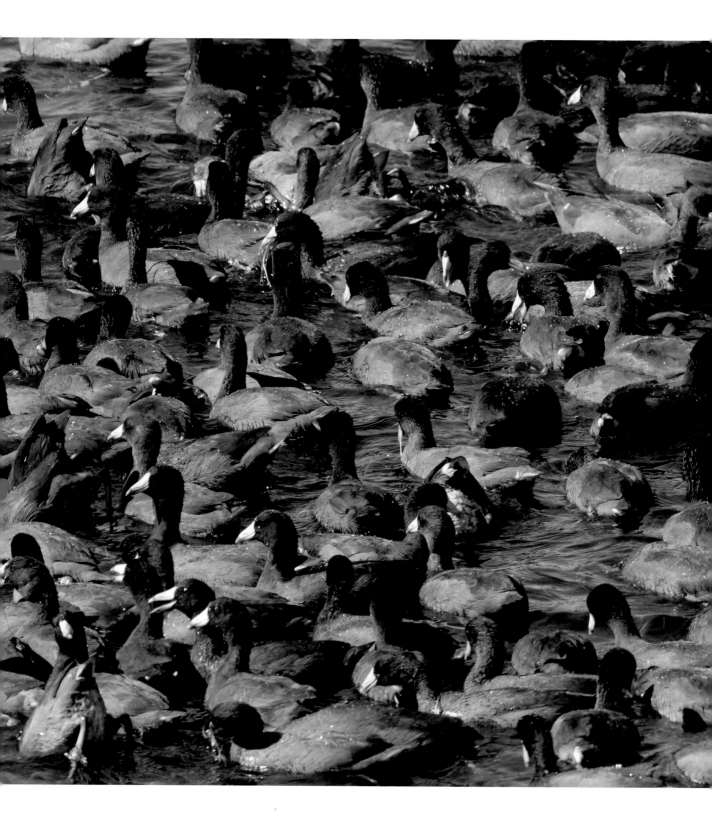

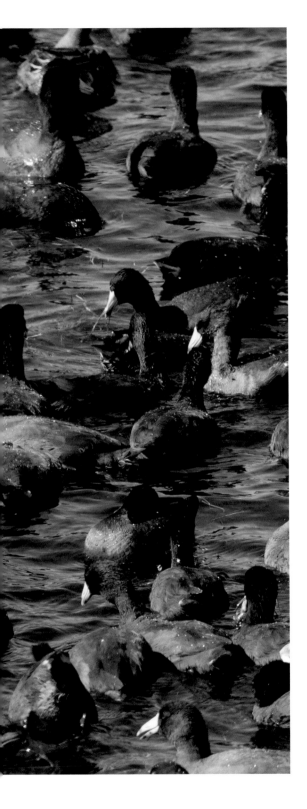

American Coot

Hickory Mound Impoundment, Taylor County, FL

"The Coot," says William Bartram, "is a native of North America, from Pennsylvania to Florida. They inhabit large rivers, fresh water inlets or bays, lagoons, &c. where they swim and feed amongst the reeds and grass of the shores; particularly in the river St. Juan, in East Florida, where they are found in immense flocks. They are loquacious and noisy, talking to one another night and day; are constantly on the water, the broad lobated membranes on their toes enabling them to swim and dive like ducks."

Wilson, *American Ornithology*, 3:211, quoting "Letter from Mr. Bartram to the author"

American Bittern

Wakulla Springs State Park, Wakulla Springs, FL

 He stands motionless, with his head drawn in upon his shoulders, and half-closed eyes, in profound meditation, or steps about in a devious way, with an absent-minded air; for greater seclusion, he will even hide in a thick brush clump for hours together.

<div style="text-align: right;">Coues, Birds of the North West, 527 (quoted in Bent, Marsh Birds, 72–73)</div>

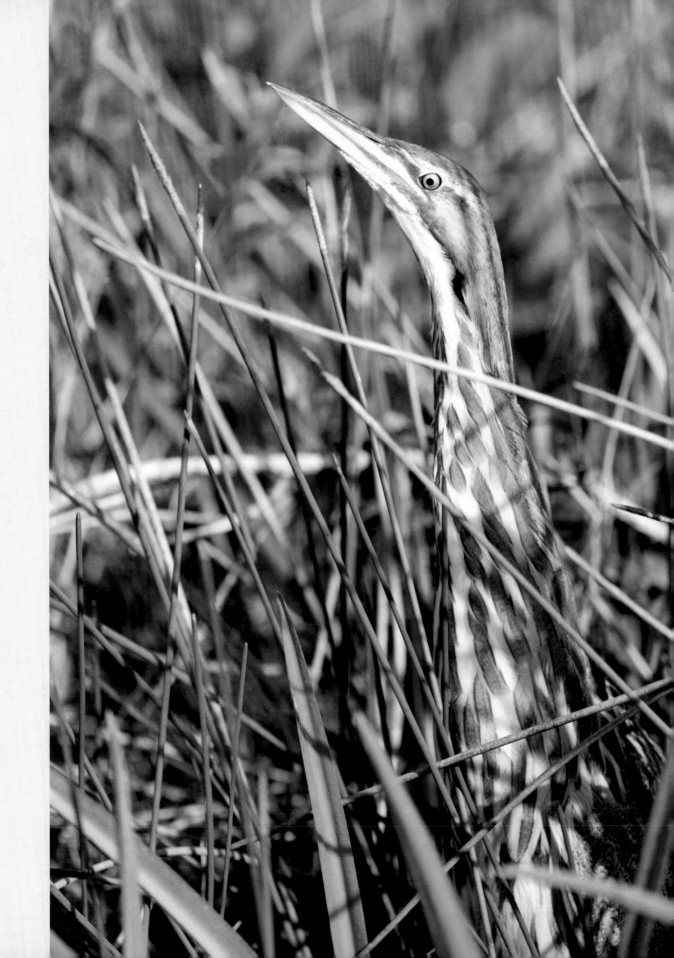

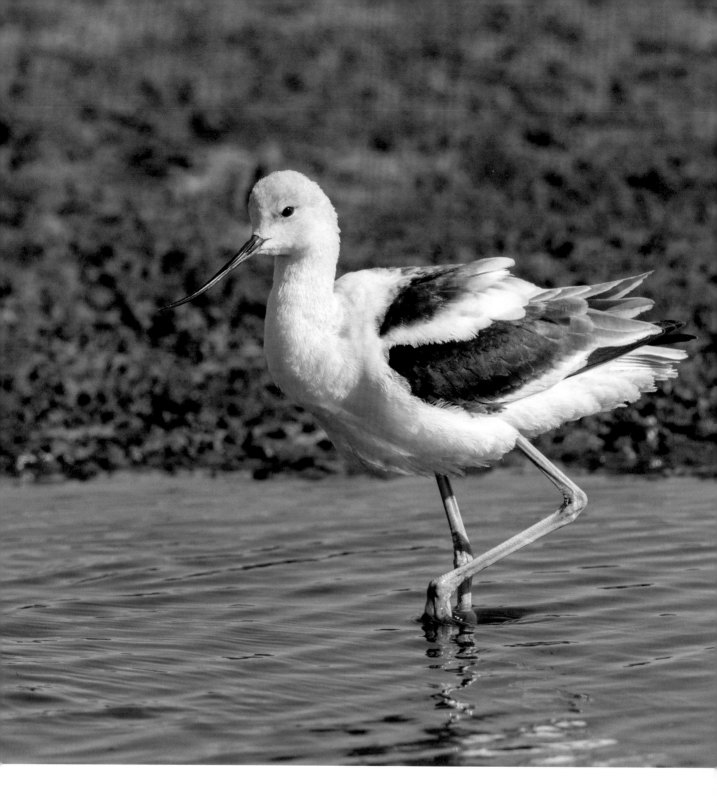

American Avocet (*opposite*)

St. Marks National Wildlife Refuge, FL

 No bird is better equipped for the amphibious existence that it leads; its long legs and webbed feet enable it to wade through soft muddy shallows of varying depths; and if it suddenly steps beyond its depth it swims as naturally as a duck until it strikes bottom again; the thick plumage of its under parts protects it and marks it as an habitual swimmer.

<div align="right">

Bent, *Shore Birds*, 1:42

</div>

Black-bellied Plover

Fort De Soto County Park, Tierra Verde, FL

 The black-bellied plover is an aristocrat among shore birds, the largest and strongest of the plovers, a leader of its tribe. It is a distinguished-looking bird in its handsome spring livery of black and white; and its attitude, as it stands like a sentinel on the crest of a sand dune or on some distant mud flat, is always dignified and imposing.

<div align="right">

Bent, *Shore Birds*, 2:154

</div>

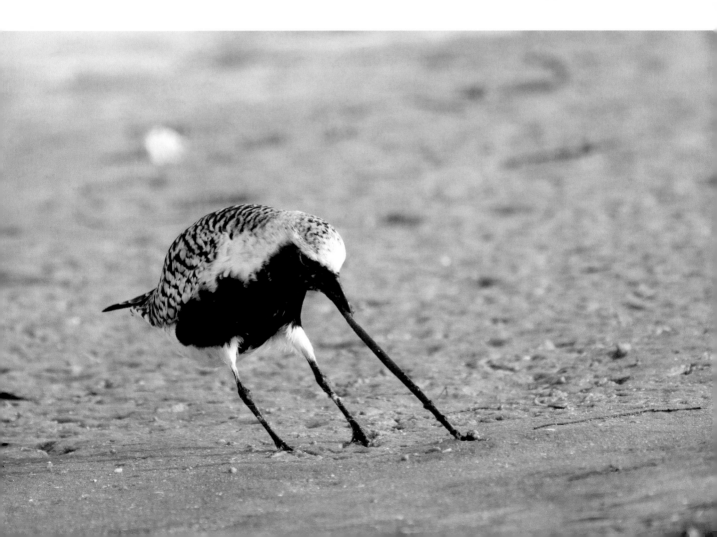

Black-necked Stilt

St. Marks National Wildlife Refuge, FL

. . . for wading they are highly specialized, and here they show to best advantage. At times they seem a bit wabbly on their absurdly long and slender legs, notably when trembling with excitement over the invasion of their breeding grounds. But really they are expert in the use of these well-adapted limbs, and one can not help admiring the skillful and graceful way in which they wade about in water breast deep, as well as on dry land, in search of their insect prey. The legs are much bent at each step, the foot is carefully raised and gently but firmly planted again at each long stride. The legs are so long that when the bird is feeding on land it is necessary to bend the legs backward to enable the bill to reach the ground.

Bent, *Shore Birds*, 1:52

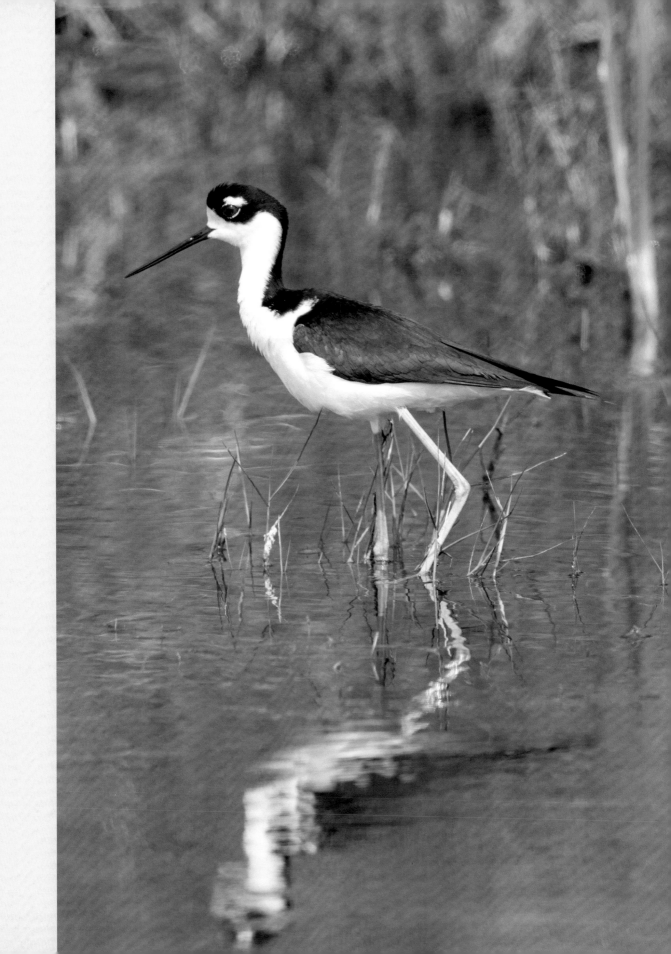

Double-crested Cormorant

Fort De Soto County Park, Tierra Verde, FL

On first coming in they alight in the water, look about a minute, and then disappear with an easy gliding dive. They generally remain under the water for about a minute. If they have been successful in their fishing, their prey can be easily seen when they reappear. They catch a fish crossways, and it takes a little manipulation and sundry jerks of the head to get it placed properly in the mouth; then there is an upward flirt of the bill and the fish is swallowed.

Bent, *Petrels*, 249

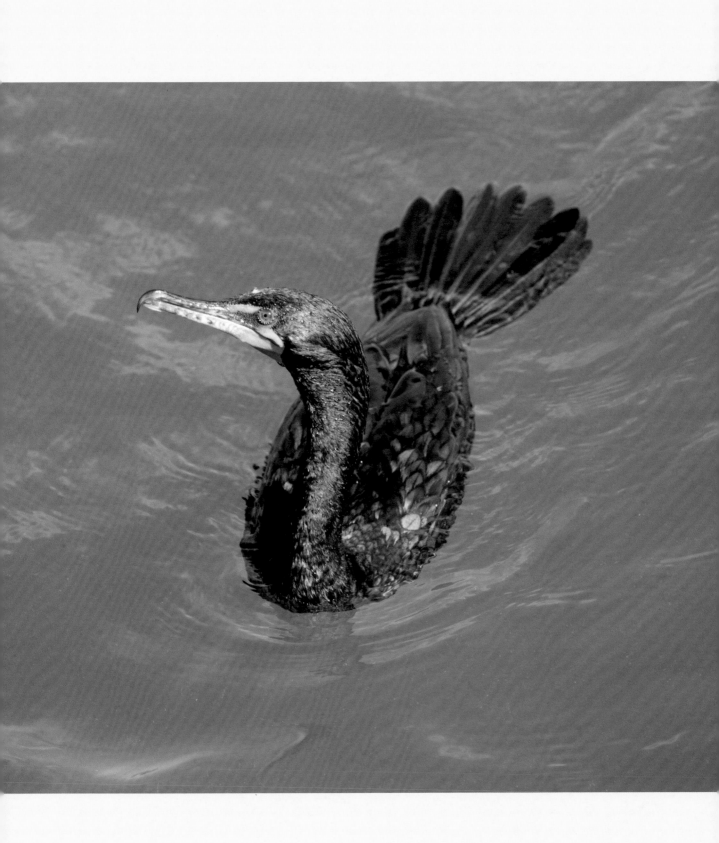

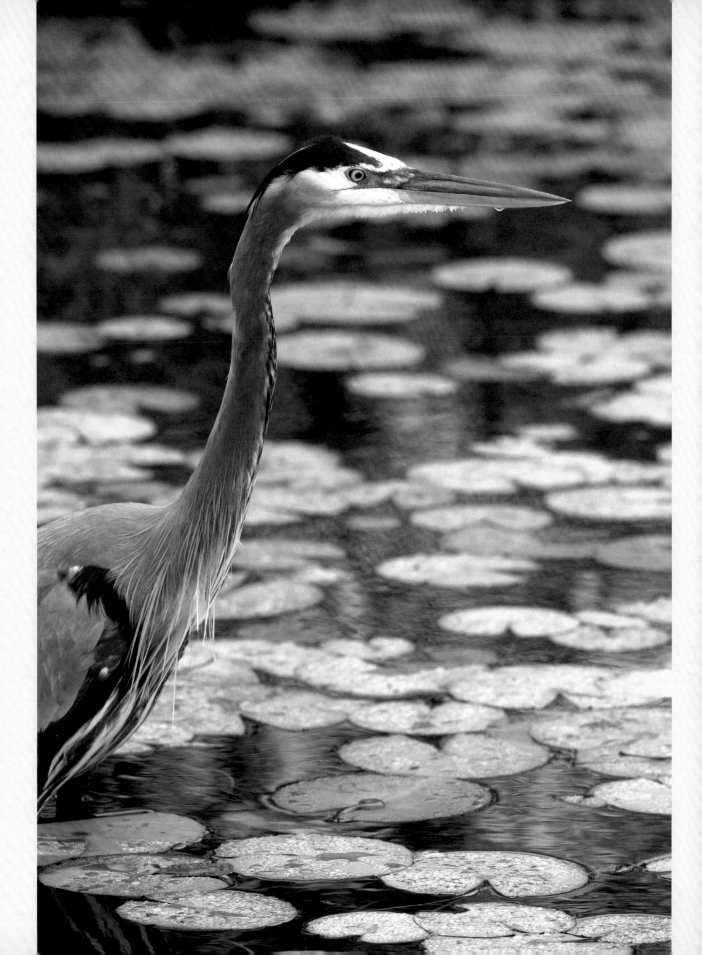

Great Blue Heron

St. Marks National Wildlife Refuge, FL

 In its native solitudes, far from the haunts of man, it may be seen standing
motionless, in lonely dignity, on some far distant point that breaks the shore line
of a wilderness lake, its artistic outline giving the only touch of life to the broad
expanse of water and its background . . .

<div align="right">Bent, Marsh Birds, 101</div>

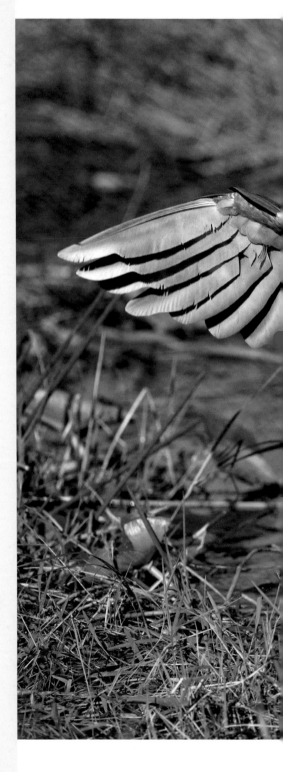

Great Blue Heron

Anhinga Trail, Everglades National Park, FL

It always strikes its prey through the body, and as near the head as possible. When the animal is strong and active, it kills it by beating it against the ground or a rock, after which it swallows it entire.

Audubon, *Birds of America*, 6:126

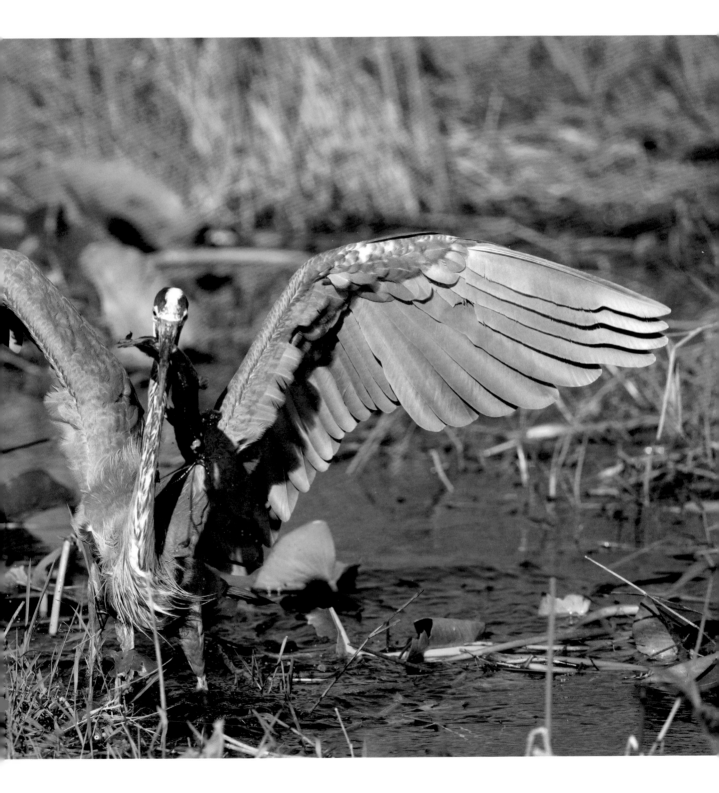

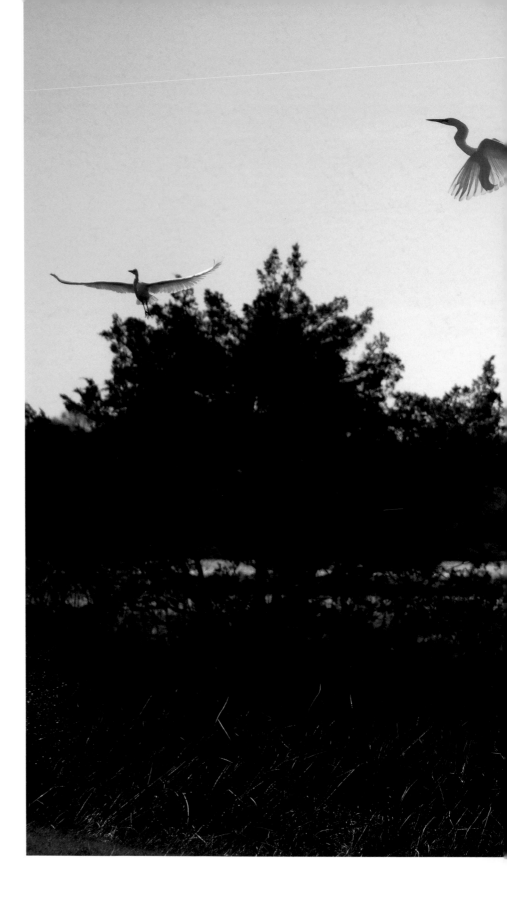

Great Egrets

St. Marks National Wildlife
Refuge, Panacea, FL

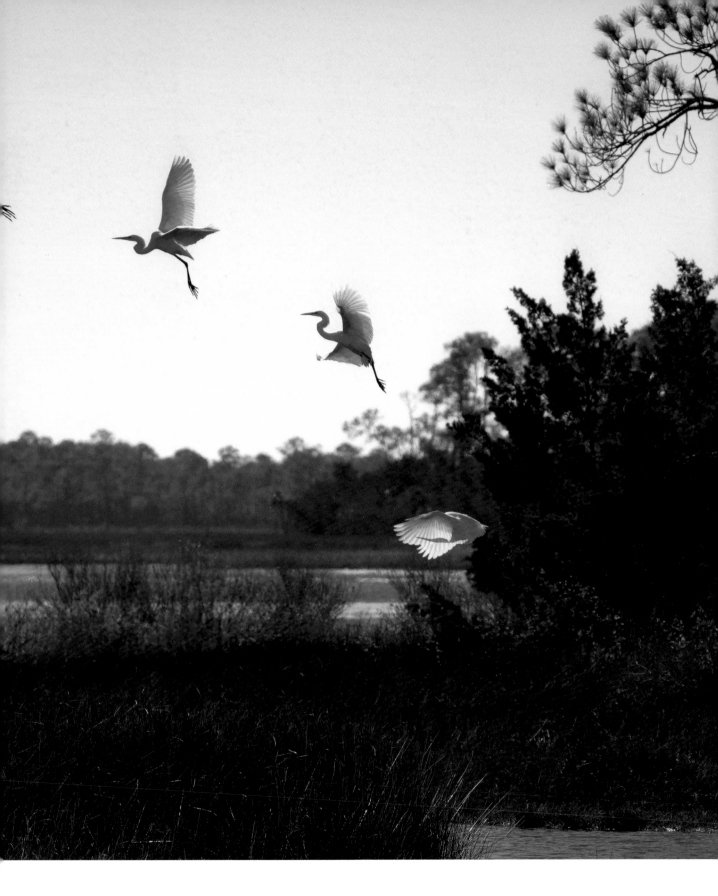

Green Heron

Wakulla Springs State Park, Wakulla Springs, FL

The [Green Heron], fixing his penetrating eye on the spot where they disappeared, approaches with slow stealing step, laying his feet so gently and silently on the ground as not to be heard or felt; and when arrived within reach stands fixed, and bending forwards, until the first glimpse of the frog's head makes its appearance, when, with a stroke instantaneous as lightning, he seizes it in his bill, beats it to death, and feasts on it at his leisure.

Wilson, *American Ornithology*, 3:68

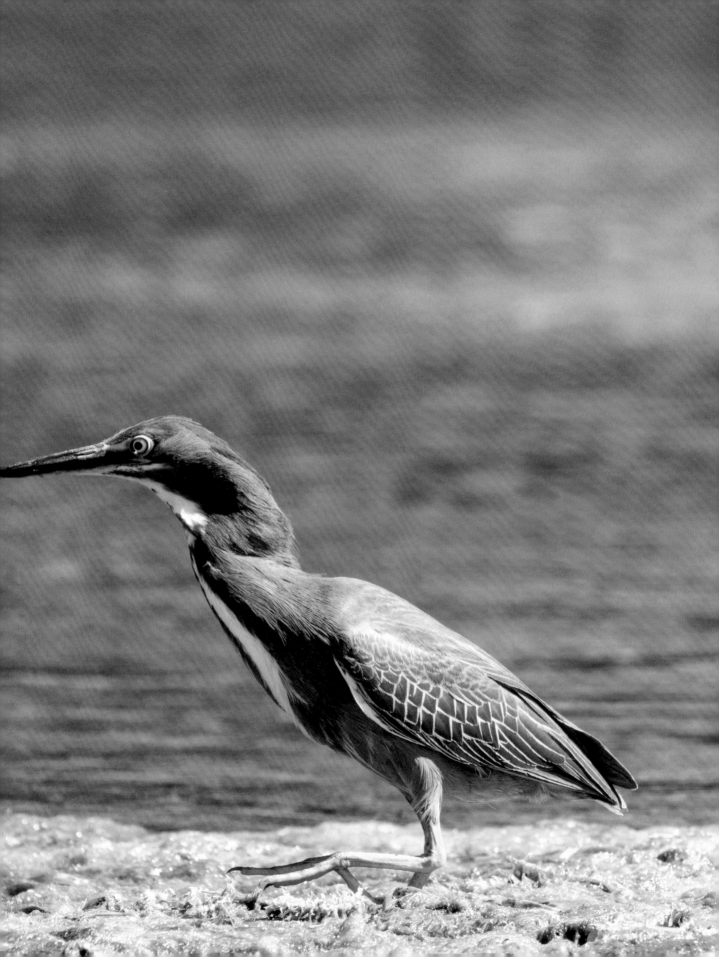

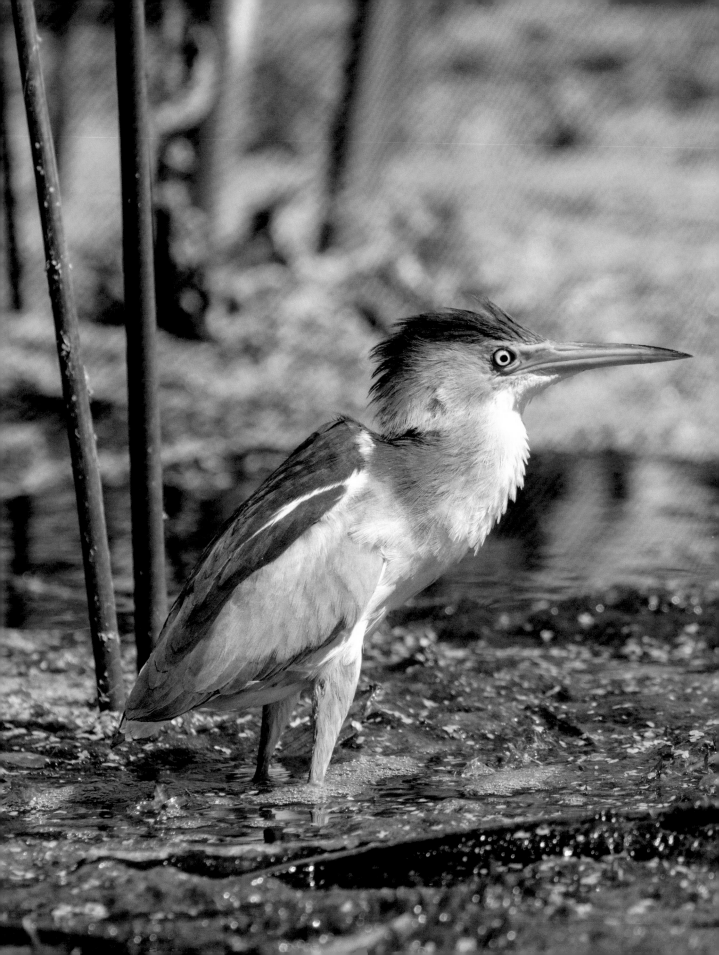

Least Bittern

Wakulla Springs State Park, Wakulla Springs, FL

When alarmed they seldom fly far, but take shelter among the reeds or long grass. They are scarcely ever seen exposed, but skulk during the day; and, like the preceding species [Green Heron], feed chiefly in the night.

Wilson, *American Ornithology*, 3:71

Osprey

St. Marks National Wildlife Refuge, FL

The last of this race I shall mention is the falcopiscatorius, or fishing-hawk; this is a large bird, of high and rapid flight; his wings are very long and pointed, and he spreads a vast sail, in proportion to the volume of his body. This princely bird subsists entirely on fish which he takes himself, scorning to live and grow fat on the dear-earned labours of another; he also contributes liberally to the support of the bald eagle.

Bartram, *Travels*, 8

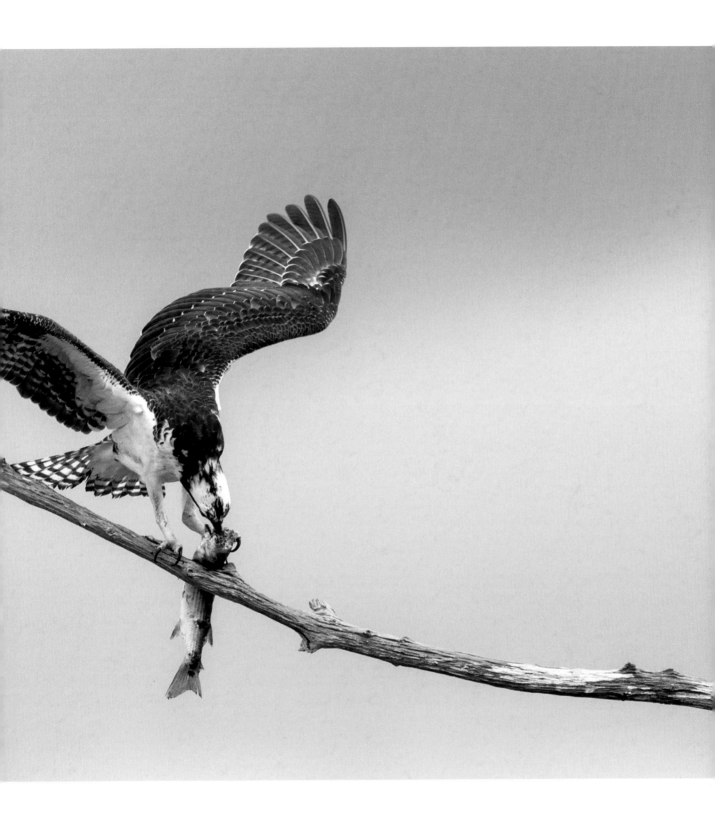

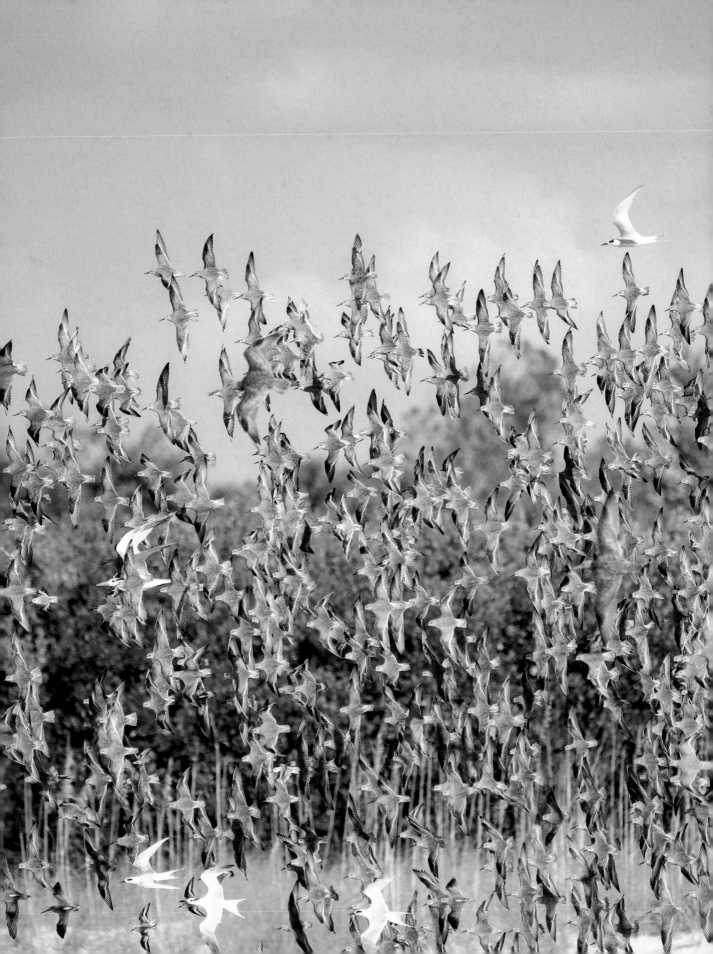

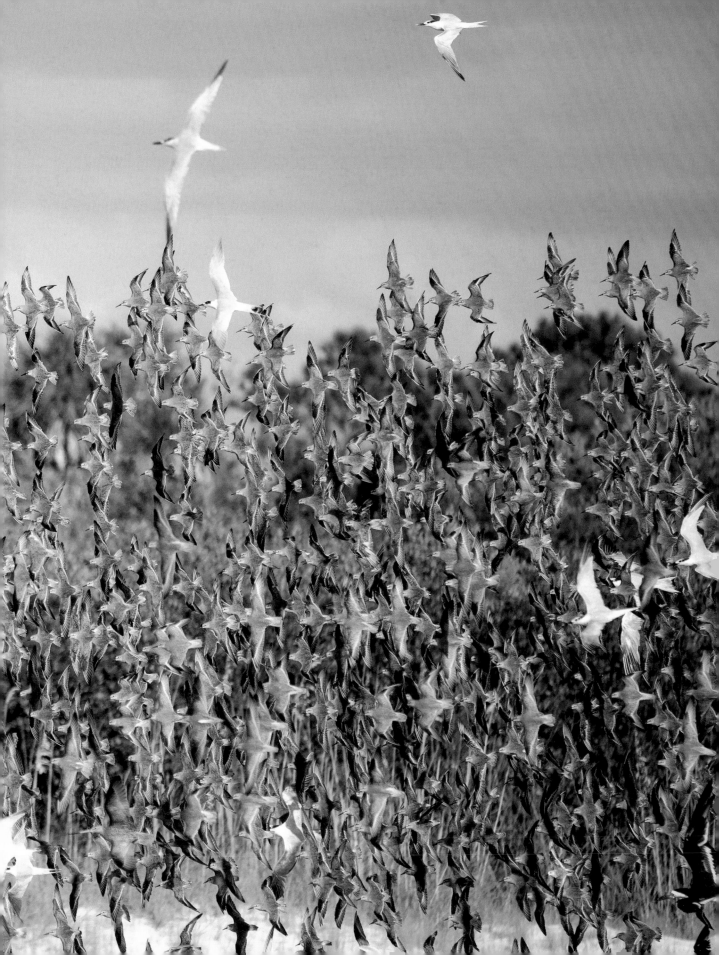

Red Knots (*previous*)

Fort De Soto County Park, Tierra Verde, FL

Its flight is swift, at times rather elevated, and well sustained. At their first arrival in autumn, when they are occasionally seen in great numbers in the same flock, their aerial evolutions are very beautiful, for, like our Parrakeet, Passenger Pigeon, Rice-bird, Red-winged Starling, and other birds, they follow each other in their course with a celerity that seems almost incomprehensible, when the individuals are so near each other that one might suppose it impossible for them to turn and wheel without interfering with each other. At such times, their lower and upper parts are alternately seen, the flock exhibiting now a dusky appearance, and again gleaming like a meteor.

Audubon, *Birds of America*, 5:255–256

Red Knot

Fort De Soto County Park, Tierra Verde, FL

In activity it . . . traces the flowing and recession of the waves along the sandy beach, with great nimbleness, wading and searching among the loosened particles for its favourite food, which is a small thin oval bivalve shell-fish, of a white or pearl colour, and not larger than the seed of an apple. . . . It is amusing to observe with what adroitness they follow and elude the tumbling surf, while at the same time they seem wholly intent on collecting their food.

Wilson, *American Ornithology*, 3:142–143

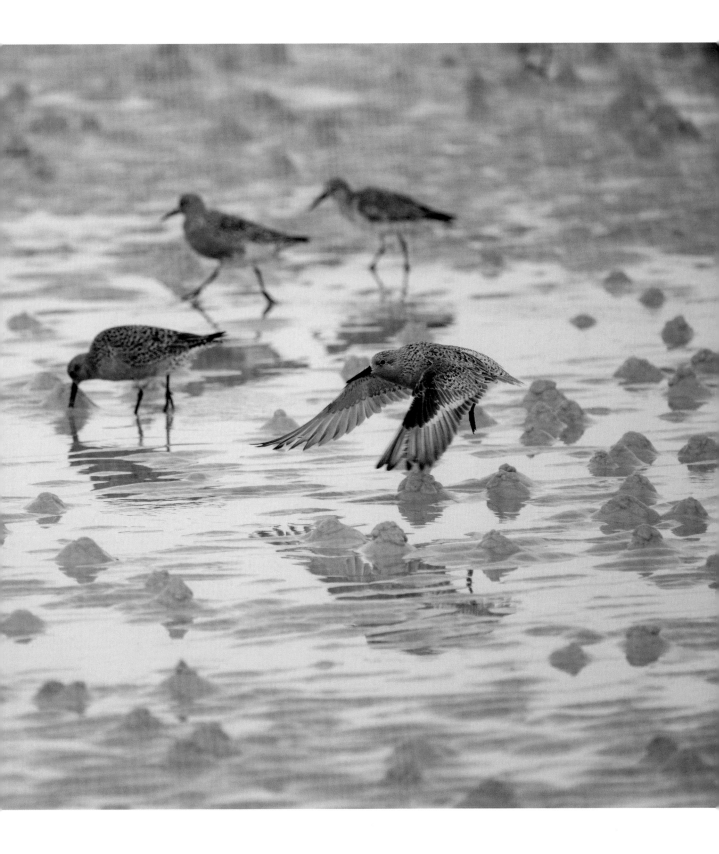

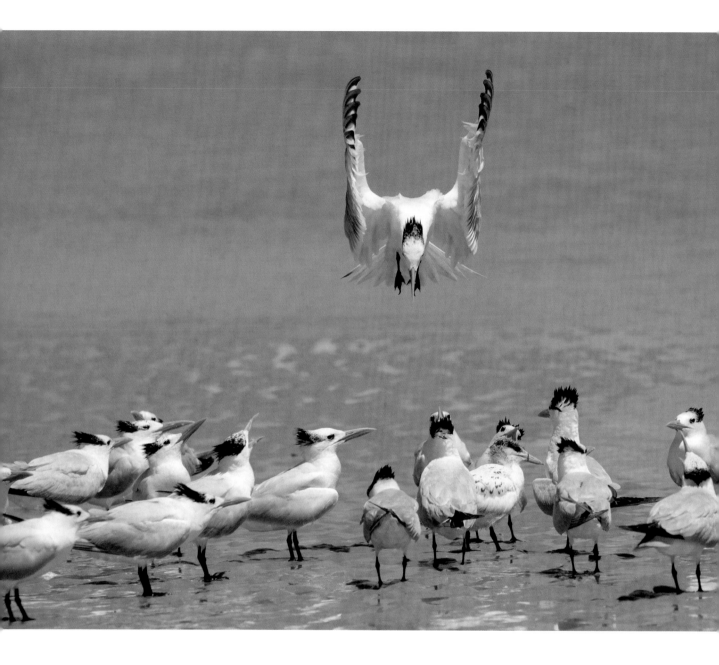

Royal Tern
Huguenot Memorial Park, Jacksonville, FL

Ruddy Turnstone (*below*)

Fort De Soto County Park, Tierra Verde, FL

It will allow no competition, in the spot where it is feeding, from another bird, even of its own species, but with lowered head, drooping wings, and hunched up back it rushes at the intruder in a threatening attitude and perhaps gives him a few jabs with its sharp bill.

Bent, *Shore Birds*, 2:289

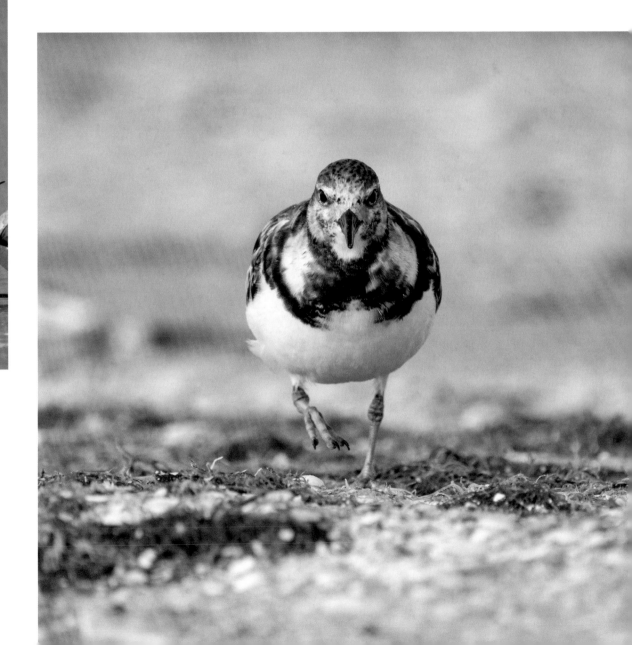

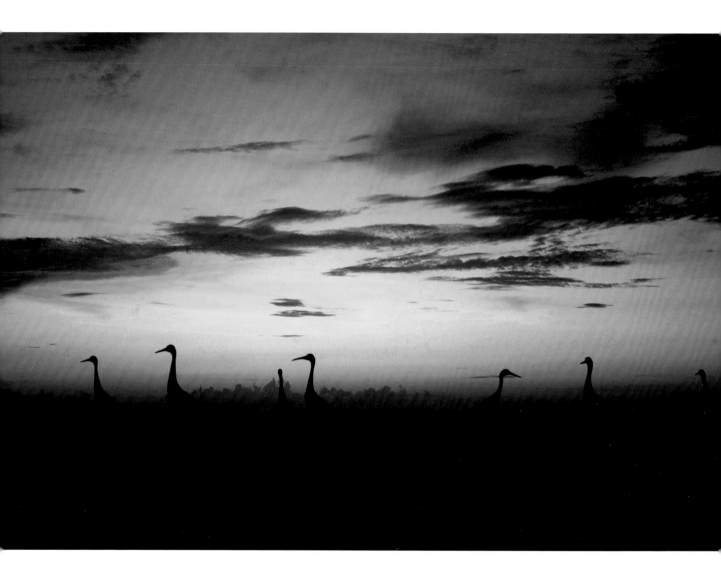

Sandhill Crane

East Lake Tohopekaliga, Kissimmee, FL

The main moves in his system are simple. Night is spent usually in the shallows of marsh or grassy pond-hole, morning and evening upon the grain fields, noon and early afternoon aloft or at pond-hole or on the prairie. His plan is the reverse of that of the geese. The goose is a water bird that comes to the uplands and fields to feed; the crane is a land bird that goes to the water merely to drink and secure a safe night roost.

Laing, "Garoo, Chief Scout of the Prairie," 703

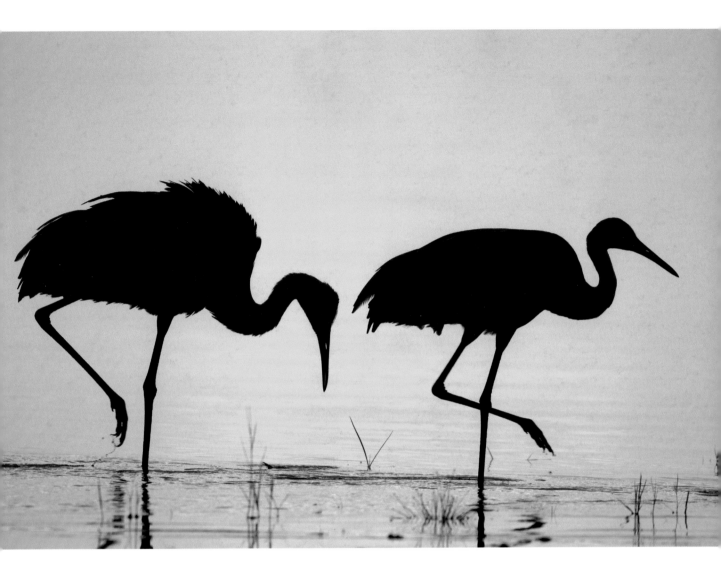

Sandhill Crane

East Lake Tohopekaliga, Kissimmee, FL

[N]ow they mount aloft, gradually wheeling about; each squadron performs its evolutions, encircling the expansive plains, observing each one its own orbit; then lowering sail, descend on the verge of some glittering lake . . .

Bartram, *Travels*, 144–145

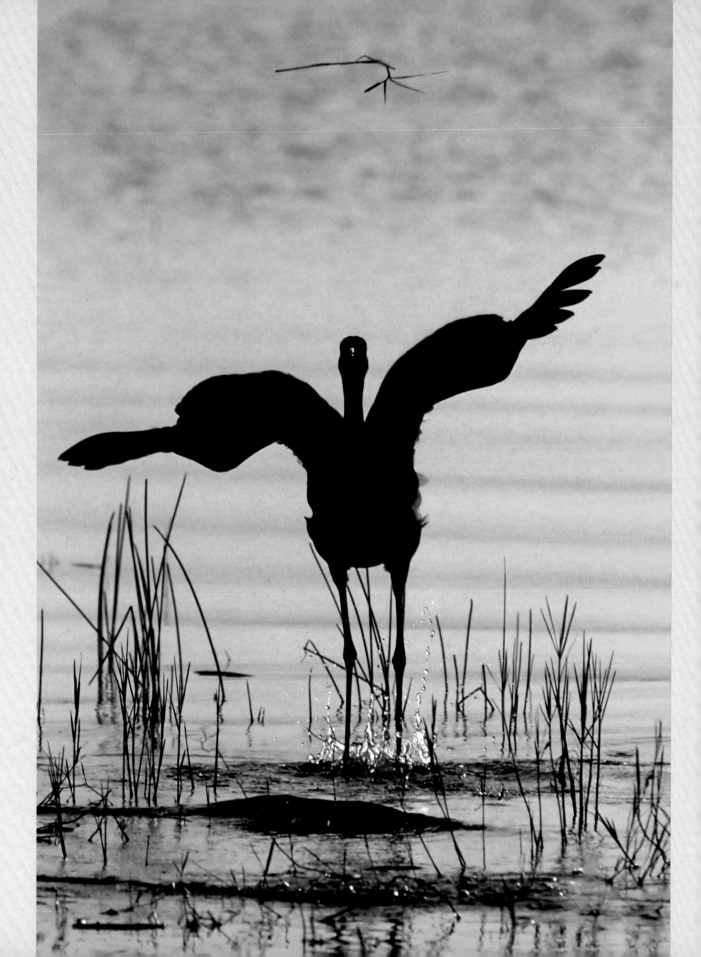

Sandhill Crane

East Lake Tohopekaliga, Kissimmee, FL

[A]s the warmer weather quickens their feeling, these majestic stalkers, these stately trumpeters, may often be seen so far forgetting their dignity as to wheel about and dance, flapping their wings and shouting as they "honor their partners," and in various ways contrive to exhibit an extraordinary combination of awkwardness and agility.

Thompson, *Birds of Manitoba*, 492

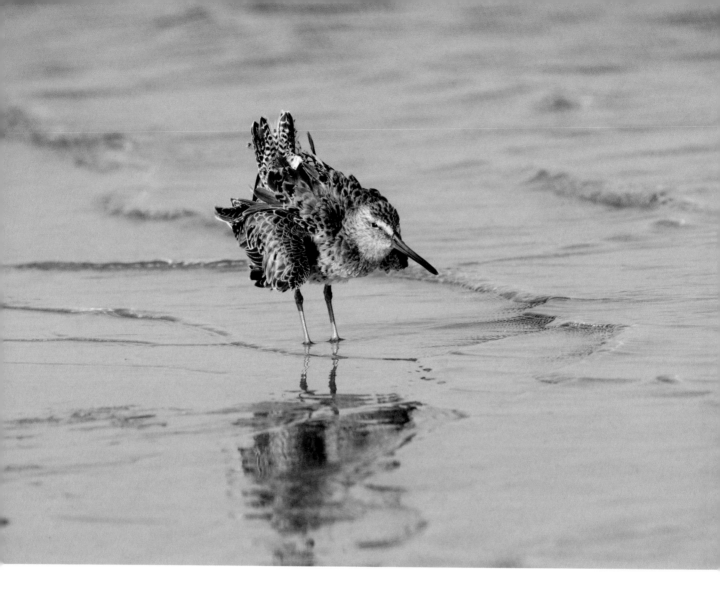

Short-billed Dowitcher

Fort De Soto County Park, Tierra Verde, FL

The favorite feeding grounds of the dowitchers are the mud flats and sand flats in sheltered bays and estuaries, or the borders of shallow ponds on the marshes, where they associate freely with small plovers and sandpipers. Although not inclined to move about actively, their feeding motions are very rapid, as they probe in the mud or sand with quick, perpendicular strokes of their long bills, driving them in their full length again and again in rapid succession; while feeding in shallow water the whole head is frequently immersed and sometimes several strokes are made with the head under water.

Bent, *Shore Birds*, 110

Snowy Egret

Bonita Beach, FL

This beautiful little heron, one of nature's daintiest and most exquisite creatures, is the most charming of all our marsh birds. The spotless purity of its snowy plumage, adorned with airy, waving plumes, and its gentle, graceful manners, make it the center of attraction wherever it is seen. While darting about in the shallow water in pursuit of its lively prey, its light curving plumes fluttering in the breeze, it is a pretty picture of lovely animation.

Bent, *Marsh Birds*, 146

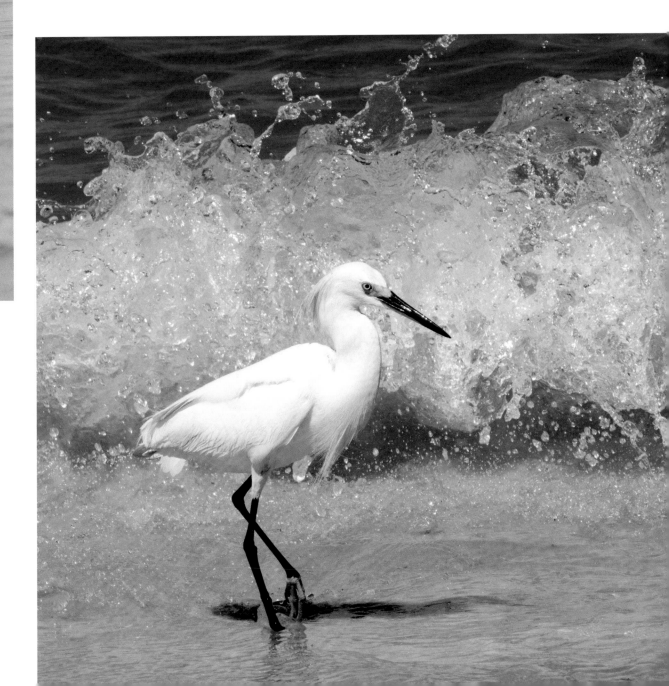

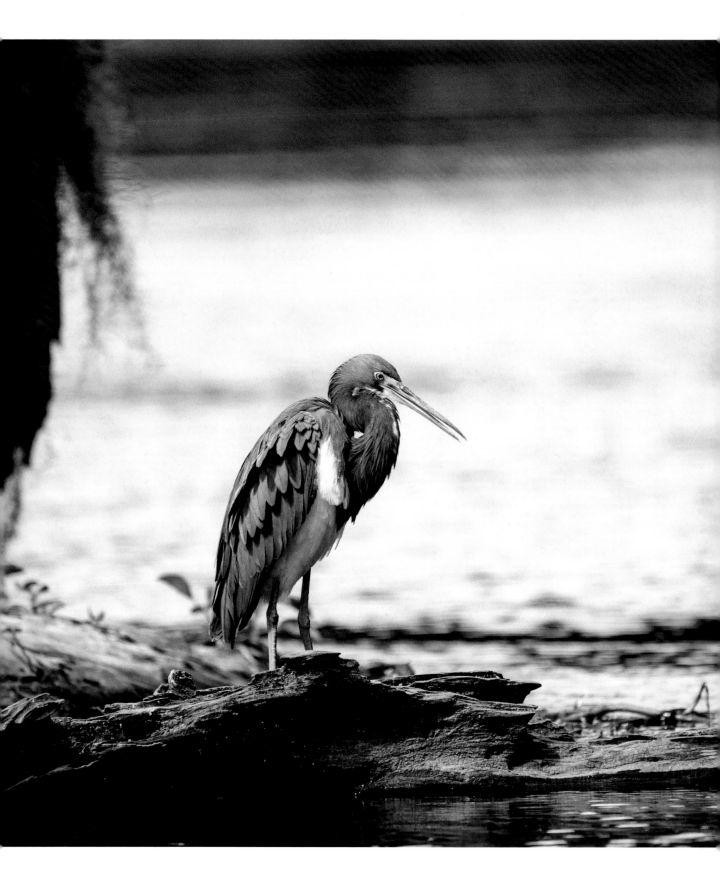

Tricolored Heron

Wakulla Springs State Park, Wakulla Springs, FL

What beautiful, dainty creatures they were, their slender forms clothed in bluish gray, blended drabs, purples, and white, with their little white plumes as a nuptial head dress. How agile and graceful they were as they darted about in pursuit of their prey. With what elegance and yet with what precision every movement was made. For harmony in colors and for grace in motion this little heron has few rivals.

Bent, *Marsh Birds*, 168

White Ibis

St. Marks National Wildlife Refuge, FL

[W]e frequently found them on inland lakes and streams, feeding in the shallow, muddy waters, or flying out ahead of us as we navigated the narrow creeks in the mangrove swamps. Once I surprised a large flock of them in a little sunlit, muddy pool in a big cypress swamp; they were feeding on the muddy shores, dozing on the fallen logs or preening their feathers as they sat on the stumps and the branches of the surrounding trees; what a cloud of dazzling whiteness and what a clatter of many black-tipped wings, as they all rose and went dodging off among the trees.

Bent, *Marsh Birds*, 23

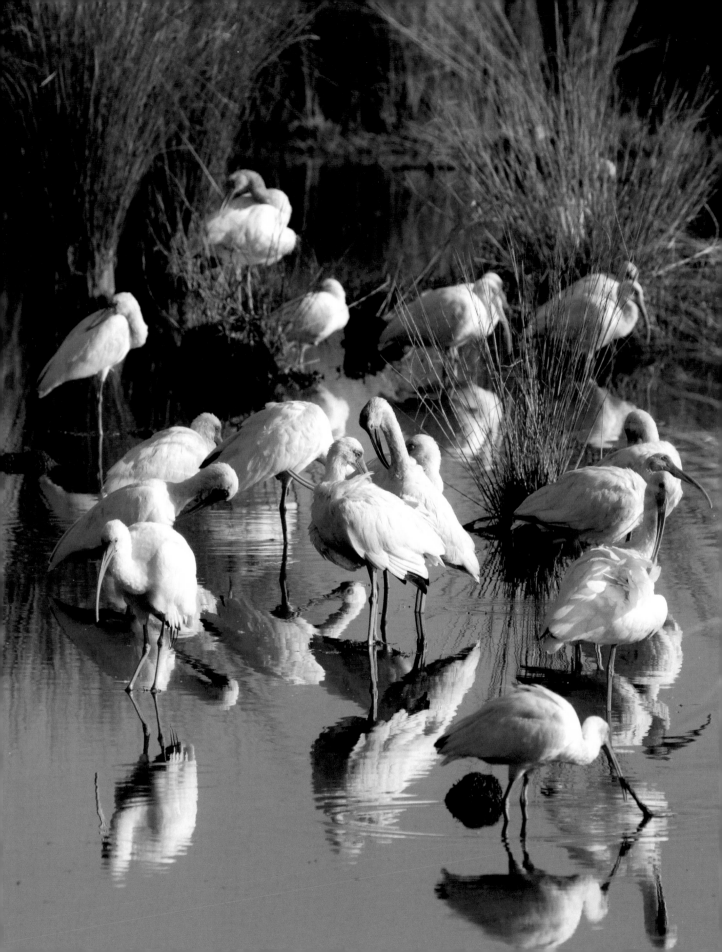

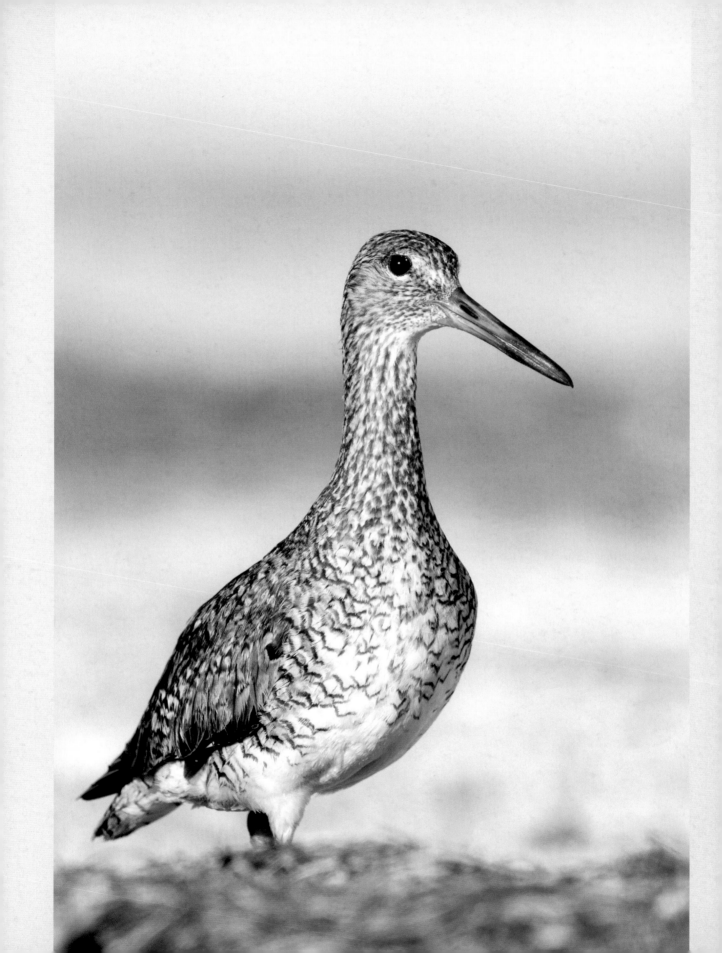

Willett

Fort De Soto County Park, Tierra Verde, FL

 In Florida they are occasionally seen about the ponds on the prairies or in the pine woods, but their favorite resorts are the broad mud flats in the estuaries and bayous or in the coastal marshes. In such places we often saw them in large flocks by themselves, where they were very shy and utterly unapproachable.

<div align="right">Bent, Shore Birds, 2:34</div>

BIBLIOGRAPHY

Audubon, John James. *The Birds of America: from Drawings Made in the United States and Their Territories*. Vols. I-VII. Philadelphia: J. J. Audubon, 1840–1844. Accessed at https://archive.org/details/birdsofamericafr01audu

Bailey, Florence Merriam. "A Populous Shore," *The Condor*, no. 18, (1916): 100–110. Accessed at https://sora.unm.edu/node/95850

Bartram, William. *Travels through North and South Carolina, Georgia, East and West Florida, the Cherokee country, the Extensive Territories of the Muscogulges or Creek Confederacy, and the Country of the Chactaws*. 2nd ed. London: reprinted for J. Johnson in St. Paul's Church-Yard, 1794. Accessed at https://archive.org/details/travelsthroughn000bart

Bent, Arthur Cleveland. *Life Histories of North American Gulls and Terns*. Bulletin of The United States National Museum 113. Washington, D.C.: U.S. Government Printing Office, 1921. Accessed at http://www.archive.org/details/bulletinunitedst1131921unit

Bent, Arthur Cleveland. *Life Histories of North American Petrels and Pelicans and Their Allies*. Bulletin of The United States National Museum 121. Washington, D.C.: U.S. Government Printing Office, 1922. Accessed at http://www.archive.org/details/bulletinunitedst1211922unit

Bent, Arthur Cleveland. *Life Histories of North American Wild Fowl*. Bulletin of The United States National Museum 130. Washington, D.C.: U.S. Government Printing Office, 1923. Accessed at http://www.archive.org/details/lifehistoriesofnawfoobent

Bent, Arthur Cleveland. *Life Histories of North American Marsh Birds*. Bulletin of The United States National Museum 135. Washington, D.C.: U.S. Government Printing Office, 1926. Accessed at http://www.archive.org/details/bulletinunitedst1351926unit

Bent, Arthur Cleveland. *Life Histories of North American Shore Birds*. Part 1. Bulletin of The United States National Museum 142. Washington, D.C.: U.S. Government Printing Office, 1927. Accessed at https://archive.org/details/lifehistoriesofn47028gut

Bent, Arthur Cleveland. *Life Histories of North American Shore Birds*. Part 2. Bulletin of The United States National Museum 146. Washington, D.C.: U.S. Government Printing Office, 1929. Accessed at http://www.archive.org/details/bulletinunitedst1461929unit

Bent, Arthur Cleveland. *Life Histories of North American Gallinaceous Birds.* Bulletin of The United States National Museum 162. Washington, D.C.: U.S. Government Printing Office, 1932. Accessed at http://www.archive.org/details/bulletinunitedst1621932unit

Bent, Arthur Cleveland. *Life Histories of North American Birds of Prey.* Part 1. Bulletin of The United States National Museum 167. Washington, D.C.: U.S. Government Printing Office, 1937. Accessed at http://www.archive.org/details/bulletinunitedst1671937unit

Bent, Arthur Cleveland. *Life Histories of North American Cuckoos, Goatsuckers, Hummingbirds and Their Allies.* Bulletin of The United States National Museum 176. Washington, D.C.: U.S. Government Printing Office, 1940. Accessed at https://library.si.edu/digital-library/book/bulletinunitedst1761940unit

Catesby, Mark. *The Natural History of Carolina, Florida and the Bahama Islands.* 2 vols. London: at the author's expense, 1731–1743. Accessed at https://ia800208.us.archive.org/33/items/naturalhistoryCC1V1Cate/naturalhistoryCC1V1Cate.pdf

Chapman, Frank M. *Handbook of Birds of Eastern North America.* 3rd ed. New York: D. Appleton and Company, 1896. Accessed at http://www.archive.org/details/handbookofbirds00ocha

Chapman, Frank M. *Camps and Cruises of An Ornithologist.* New York: D. Appleton and Company, 1908. Accessed at http://www.archive.org/details/campscruisesoforoochap

Coues, Elliott. *Birds of the North West.* United States Geological Survey of the Territories, Miscellaneous Publications no. 3. Washington: U. S. Government Printing Office, 1874. Accessed at https://ia802709.us.archive.org/28/items/birdsofnorthwest00coue/birdsofnorthwest00coue.pdf

Gosse, Philip Henry. *The Birds of Jamaica.* London: John Van Voorst, Paternoster Row, 1847. Accessed at https://ia800300.us.archive.org/34/items/birdsofjamaica00goss/birdsofjamaica00goss.pdf

Laing, Hamilton M. "Garoo, Chief Scout of the Prairie." *Outing* LXVI (1915): 699–710. Accessed at https://macklaingsociety.ca/wp/wp-content/uploads/2014/11/OutingMagazine1915Vol66.pdf

Maynard, C. J. *The Birds of Eastern North America.* Newtonville, Mass.: C. J. Maynard & Co., 1896. Accessed at http://www.archive.org/details/birdsofeasternn00omayn

Nelson, Edward W. *Report upon Natural History Collections Made in Alaska between the Years 1877 and 1881.* Arctic Series of Publications Issued in Connection with the Signal Service, U.S. Army. Washington, D.C.: U.S. Government Printing Office, 1887. Accessed at https://archive.org/details/reportuponnatura00nelso/page/n3/mode/2up

Nichols, John Treadwell. "Bird Notes from Florida." *Abstract of Proceedings, Linnaean Society of New York* 30 (1918): 20–27. Accessed at https://www.biodiversitylibrary.org/item/49176#page/7/mode/1up

Nuttall, Thomas. *A Manual of the Ornithology of the United States and of Canada, The Land Birds.*

Cambridge: Hilliard and Brown, 1832. Accessed at http://www.archive.org/details/manualof ornitholo1nutt

Nuttall, Thomas. *A Manual of the Ornithology of the United States and of Canada, The Water Birds.* Boston: Hilliard, Gray, and Company, 1834. Accessed at http://www.archive.org/details/ manualofornitholo2nutt

Sprunt, Alexander F. "Eastern Boat-Tailed Grackle." In *Life Histories of North American Blackbirds, Orioles, Tanagers, and Allies,* by Arthur Cleveland Bent. Bulletin of The United States National Museum 211. Washington, D.C.: U.S. Government Printing Office, 1958. Accessed at http:// www.archive.org/details/bulletinunitedst2111958unit

Thompson, Ernest E. "The Birds of Manitoba." *Proceedings of the United States National Museum* XIII: 457–643. Washington, D.C.: U.S. Government Printing Office, 1891. Accessed at http:// www.archive.org/details/cihm_30625

Wilson, Alexander. *American Ornithology; or, The Natural History of The Birds of the United States.* 3 vol. New York: Collins & Co., and Philadelphia: Harrison Hall, 1828–1829. Accessed at http:// archive.org/details/americanornithol1828wils and http://archive.org/details/american ornithol1829wils

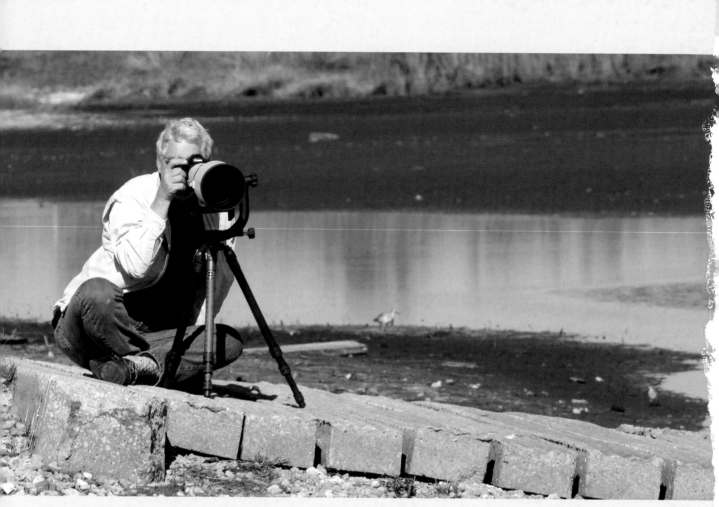

Photo credit: Don Quarello

An archaeologist by profession, Jim Miller has explored Florida's natural lands and waters for decades. He has combined his lifelong interests in art and natural history to create bird photographs that convey the unique emotions that natural Florida evokes. His work has been shown in galleries and museums throughout the state.